M000286422

HAUNTED
CENTRAL GEORGIA

HAUNTED
CENTRAL GEORGIA

JIM MILES

Published by Haunted America
A Division of The History Press
Charleston, SC
www.historypress.net

First published 2017

ISBN 9781540226563

Library of Congress Control Number: 2017940952

To my in-laws, Sarah and Earl, for producing my wife, Earline, and her yin-yang sisters, Barbara and Mercena.

CONTENTS

CONTENTS

Introduction

I have been gathering materials about paranormal Georgia since my teenage years, and that was some time ago. Over the past ten years, I have labored on a daunting project: collecting a ghost story from each of Georgia's existing 159 counties, plus two counties that went bankrupt during the Great Depression. My wife, Earline, and I crisscrossed this huge state to record firsthand ghostly encounters, search hundreds of old vertical files at libraries and scour two hundred years of Georgia newspapers and magazines, as well as every book relating to Georgia.

For these books—*Haunted North Georgia, Haunted Central Georgia* and *Haunted South Georgia*—I have found stories dating from the present back to prehistoric times, always looking for unique stories with unusual details and largely avoiding the more common ghost tales. Some of the longest stories are from the least-known and least-populated Georgia counties, while several of the shortest originated in the crowded counties around the big cities. These books are about all of Georgia, from rural to metropolitan. Think of this as state folklore, from the remotest past of Georgia to the present.

These books will appeal to those intrigued by the supernatural, as well as to anyone who embraces the entire Georgia experience and desires to learn a piece of folklore from each of our many small counties. Readers will learn that ghost tales are universal, varying little between regions, centuries and cultures.

My long manuscript has been divided into three books, organized geographically. Georgia is generally divided into three regions. North

INTRODUCTION

Georgia is the mountains; Central Georgia is the piedmont and fall line, which connects the cities of Columbus, Macon and Augusta; and South Georgia is the coastal plain, including Savannah and the coast. These regions are geographic in nature, but here we pull North Georgia down to include Metro Atlanta and Central Georgia is extended farther south simply because the coastal plain is so large. Each book contains roughly equal numbers of counties.

As you read, consider Georgia as one large community and not as isolated parts. During your next break, head for a region that you aren't familiar with and get better acquainted with our people.

BALDWIN COUNTY

THE MEANEST MAN IN GEORGIA

The Breedlove-McIntosh-Walker-Fraley-Scott-Tate Mansion, located at 201 North Jefferson Street, was home to the meanest man in Milledgeville, at least according to Katherine Scott, a resident of the house who wrote the story ten years before her 1988 death at age ninety-three. She considered Samuel Walker to be "one of the few entirely wicked men I ever heard of." He married thrice and outlived each wife, inheriting considerable estates from each.

"This strange, wicked and ruthless man seemed to have loved only two things: roses and Alice [a niece]," Scott continued. "His son, Joe, he disliked and distrusted. The boy was sent to Mercer in Macon, where he was to study law." When the school closed due to a typhoid fever epidemic, the boy returned home sick. Despite his illness, Walker immediately dispatched him to oversee Boynton, his plantation across the Oconee River. Joe returned three days later, extremely sick, but Walker, considering illness to be a character flaw, dismissed him to bed.

Walker ignored the suffering boy. Near the end, a feverish Joe struggled to the head of the stairs and told his father that he was dying. Walker ordered him back to bed, but Joe collapsed and fell down the stairs to his death. Within a week, Walker's wife and niece had also died.

Many people believe that Joe's death is reenacted every night. "Whether that be true or not," Scott wrote, "often in the night we have heard a dull 'thud' such as the boy's head might have made striking the step. Certain it is that someone goes up and down the steps at night." Another haunted spot is

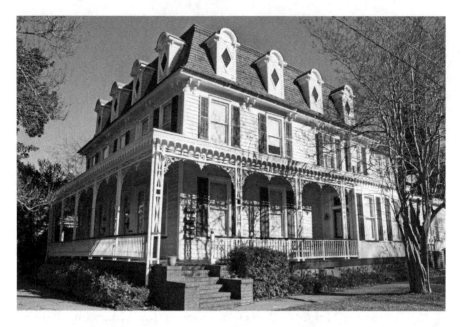

The "meanest man in Georgia," Sam Walker, lived in the Tate Mansion in Milledgeville. The house is haunted by his neglected son. *Earline Miles*.

the northwest bedroom, "where the boy, Sam's third wife and her little niece were so ill." There is "still a feeling of pain and grief."

For a *Georgia* magazine article, photographer Charles Rafshoon set up a camera on the stairs, timed to expose an infrared frame at midnight. The camera captured the fuzzy outline of what is thought to be Sam Walker. Rafshoon felt an icy chill when he saw the image on the negative.

Scott once claimed that an Atlanta reporter "hightailed it out of here in the middle of the night when Sam shoved a chifforobe across his room." He didn't "even bother to say goodnight, and I haven't heard from him since."

Of the ghost of Sam Walker, Scott reported, "I've heard and felt him around me too many times." After Scott fell and broke a hip and was released from the hospital, she was placed in the bed where Joe suffered before his death. "Night after night I had the feeling there was something black and formless standing in the doorway. The room would be saturated with an overpowering feeling of sadness and grief."

The *Georgia* magazine reporter spent a night at the house, sleeping easily through a rainy evening, but then came the presence. "Sometime in the middle of the night the tassels of the bed's canopy sway as though in an evening breeze," he wrote. "The unseen presence of something crosses the

room, and there is a loud crash on the staircase. Shortly before dawn, there is another crash."

Morning revealed Walker's mischief. A portrait of General Thomas Harrison, Oliver Cromwell's aide and a relative of Scott's, had been thrown from a wall and smashed on the floor. The support nail and wire were left in place and undamaged.

One night, as Scott and her longtime companion, Frances Lewis, slept in the house, they were awakened by a terrible sound. Alarmed that a burglar had broken in, the ladies called the police. "I went with them," Scott told Charles Salter, the Georgia Rambler from the *Atlanta Journal Constitution* (September 10, 1978), "and we found a very fine, peacock fan that had been taken from a temple in China and sent to me by an Army officer friend years ago." She had framed the fan, and now it was shattered to pieces. Scott believed that vandalism was committed by Miss Sue, one of six children of Peter J. William, the man who built the house.

Early one morning, at about 2:00 a.m., a neighbor let his dog outside and "said a woman appeared on this side of the house and came from behind some bushes and stood at the steps a few minutes," Scott said. "She was in an old-timey costume and wore high button-up shoes. He knew it must be Miss Sue. Then she turned around and vanished."

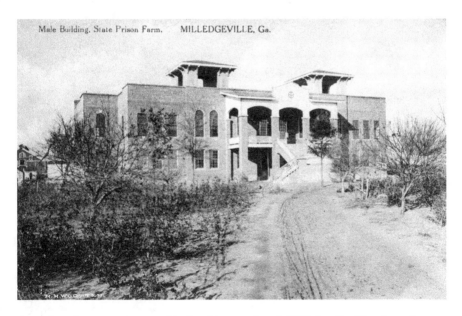

A number of men were executed in the old state prison in Milledgeville. Ghostly stories are still told of the long-empty building. *Author's personal collection.*

Scott often heard footsteps on the two primary levels of the house and many times felt someone waiting for her as she rounded a corner. While reading at night, she believed a presence observed her. That feeling was reinforced by the behavior of her bulldog, Bubbles, which, while sitting beside her, looked toward that door as if anxious to see who had just entered the room.

Scott was born on November 26, 1894, in Milledgeville and spent much of her life there. She earned a teaching degree from Georgia Normal and Industrial College (which evolved into Georgia College and State University) and a master's degree from Columbia and then taught for forty-two years. For thirty-four years, she was professor emeritus at Georgia College. Scott wrote extensively on local history, and her papers are preserved at the Georgia College library.

BIBB COUNTY

THE ROAD GOES ON FOREVER AT THE BIG HOUSE

Nathaniel Harris accomplished a great deal in his lifetime, serving as the last governor of Georgia who had fought for the Confederacy (1915–17) and helping found Georgia Tech, which he attempted to locate in Macon. In 1900, he constructed a fine home at 2321 Vineville Street, a three-story English Tudor with six thousand square feet in eighteen rooms, including an open third-floor ballroom with stained-glass windows and a crystal chandelier. It was an elegant, majestic home.

In the late 1960s, the Allman Brothers Band (ABB) set up residence in Macon to record at Capricorn Studios. In December 1969, Linda Oakley, wife of bassist Berry Oakley, saw an ad for this rental property, donned her best "little homemaker" dress and, with their adorable infant in tow, charmed the salesman and signed a contract. Shortly, Linda, Berry, Duane Allman, Gregg Allman and many others who came and went occupied the house. The walls of the sunroom were insulated to muffle late-night jams. Numerous songs were written in the house, and the many rehearsals helped evolve the unique ABB sound.

Unfortunately, during their residence, Duane and Berry were killed in separate motorcycle accidents, and in January 1973, the realty company finally realized what "undesirables" were occupying the house and evicted them. The structure has since become an icon in rock-and-roll history, known as "the Big House."

Kirk West, road manager for the Allmans and long a collector of ABB memorabilia, married Kristen in Chicago, and they moved to Macon,

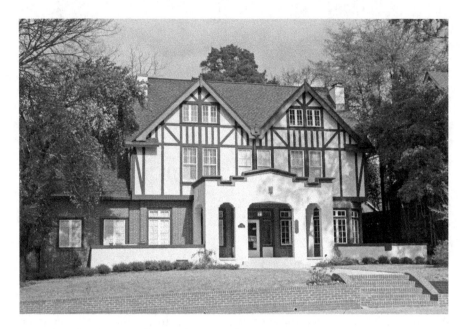

The Allman brothers once lived in this 1900 Macon home, where a female ghost floats above the faces of sleepers. *Jim Miles.*

seeking a suitable house where Kirk's collection could be displayed. To their astonished delight, they found the Big House for sale. In August 1993, they purchased it and began a long and expensive renovation. The couple quickly realized that this home came with a resident ghost, a woman from the Victorian era whose manifestations were not only frightening but also dangerous.

"I kept tripping and falling on the stairs," Kristen told Mary Lee Irby in *Macon Ghosts.* One stumble left her bedridden for three months with a ruptured disc. During a conversation with the previous owners of the residence, Kristen learned that "the wife also experienced the same thing." The pushes, shoves and falls, also inflicted on the Wests' guests, all occurred at the same place on the stairs. At one point, Kristen realized that spindles on the rails at that point were replacements, different from the originals. This finding leads one to wonder whether the resident spirit met her demise here in a tragic accident. Former owners had religious officials in to bless the house, apparently to no avail.

The Big House ghost also removes personal items, returning them days or months later, either to the place they were removed from or different,

and rather odd, locations. On two occasions, Kristen's lost car keys have been located directly under the center of a bed. A visitor also experienced the same phenomenon. Makeup Kristen used daily vanished, only to return to its proper place at a later date. Brushes and other personal items were also affected.

On the stairway landing is a servant's door and stairs to the kitchen that are never used anymore. Kristen has awoken to find the door open. A film documentarian woke up one morning and was making her bed when she saw the door open itself.

The Wests had three dogs, two named for ABB songs: Liz ("In Memory of Elizabeth Reed"), Martha ("Little Martha") and Maggie, which often alerted to supernatural phenomena undetectable to Kristen and Kirk. A house sitter once watched a shadow move rapidly up the stairs, eagerly pursued by the dogs. On another occasion, while the sitter watched television around midnight, the sleeping dogs simultaneously sat up and began to growl.

The Wests are convinced that the responsible ghost is a girl. A friend of the Wests, who originally came as a student making a documentary, had multiple dreams of the ghost, whose name she believed to be Catherine. In the dreams, a screaming woman ran down the stairs of the house.

Duane Allman and Berry Oakley, killed in the early 1970s in motorcycle wrecks in Macon, rest at Rose Hill. Gregg Allman is buried adjacent to this plot. *Earline Miles.*

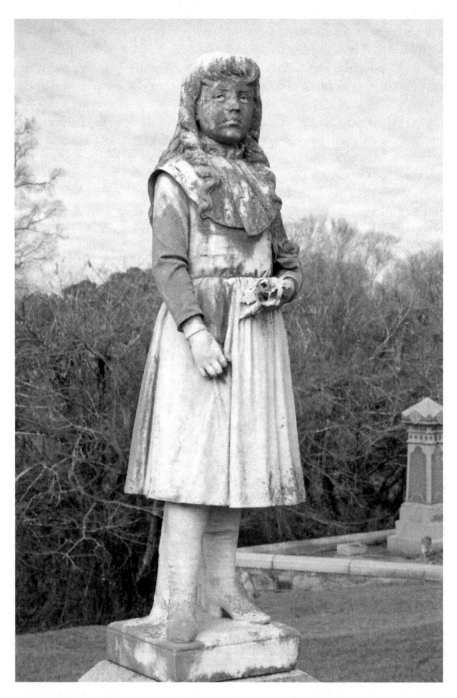

The statue of Little Martha at Rose Hill Cemetery inspired the Allman Brothers' instrumental "Little Martha." The bandmates often roamed the cemetery grounds. *Earline Miles.*

After she moved in, Kristen contacted Linda Oakley for tales of the band's residence there. Linda provided Kristen with her first ghost story.

"She [Linda] used to wake up in the middle of the night and see a female ghost hovering over her bed," Kristen told Jeff Sutton for *Macon* magazine. Kristen has witnessed the same specter. Awakening one night from a sound sleep, she first noticed the room illuminated by bands of light. Suddenly she saw the ghost, which floated just above her. "I could see this face looking at me." The figure was relaxed, stretched out in the air over the bed, with its head resting on one hand. The figure looked to be about fifteen, wearing an old-fashioned bonnet and a long dress with ruffles down the front. Remarkably, Kristen had the presence of mind to ask, "Who are you?" Still more incredible, the girl answered cryptically, "My daddy's house has five bedrooms," and quietly departed.

"She's very mischievous, but mostly with women," Kristen noted. "She's shown herself to men, but most of the mischief is with women."

Another close encounter was experienced by Kristen's dad, Charles Olsen. One morning, he told her that he observed a figure standing by his bed before flying over him to stand on the other side of the bed. Several months later, he witnessed the same apparition his daughter had encountered—a similarly dressed girl in the same clothing lying extended with head in hand. Instead of addressing her, Olson leaped from bed and stared at the apparition for several seconds before it disappeared.

Kirk's father was awakened one day by the smell of baking cinnamon buns. He was disappointed to find no one in the kitchen and no baking activity underway. A visiting *Chicago Sun Times* music critic had an identical experience with the smell of baking in the morning, Kristen said.

"Someone died here, but I don't know who it is," stated Kristen.

After years of effort, the Big House was restored and opened as the Allman Brothers Band Museum at the Big House, 2321 Vineville Avenue. It is open Thursday through Saturday, 9:00 a.m. to 5:00 p.m., and admission is charged. The Big House Foundation, PO Box 4291, Macon, GA 31208-4091; (478) 741-5551; www.thebighousemuseum.com.

BLECKLEY COUNTY

PLEASE DON'T GO, GRANDDADDY

Barbara S. Guthrie was a native of Cochran. In 1955, she, her husband and their four-year-old son, Edward, moved to Salem, Virginia. Edward was the youngest grandchild for the Guthries' parents, and the boy and her father, Rufus Goody Sr., "were inseparable," Guthrie wrote in *FATE* magazine in March 1976. To lessen the blow, Edward's parents promised to send him to Cochran each summer to spend several months with his beloved grandparents. That promise was faithfully kept.

As time passed, Goody had a stroke but was able to get around with the aid of a cane. In his seventies, his condition worsened, and he was dependent on a wheelchair. His disability never hampered the "great time together" he and Edward enjoyed each summer.

After one visit, Edward had returned home from Georgia in July 1963. During the night of August 19, Guthrie was awakened when "I heard him cry out in his sleep." It was just past midnight as she donned her housecoat and hurried down the hall to her son. "As I neared his room I heard him say, 'Oh, Granddaddy, don't go!'" she wrote. "'Please don't go!'"

She continued: "The room was dark and unusually cold, although the rest of the house seemed quite warm. When I switched on the light I found Edward, now 12-years-old, in bed on his knees with his hand stretched out toward something I could not see."

Believing that he was asleep and in the grip of a nightmare, Guthrie gently shook his shoulder, telling him that it was only a dream and to wake up. "He shrugged my hand off and crawled to the foot of the bed. 'Please don't go,

Granddaddy,' he sobbed. Finally he collapsed against the foot of the bed, crying as if his heart would break. I tried to convince him it was only a dream but he shook his head. 'He's gone, Mama. I can't see him anymore.'"

Early that morning, Guthrie received a call from Georgia. Her father had died during the night. "Papa Goody never visited Virginia when he was alive," Guthrie concluded, "but he came at the time of his death to tell Edward goodbye," all the way from Cochran.

BULLOCH COUNTY

A GHOST LIGHT WITH EXTRAS

R oger Allen writes a column about the history of Bulloch County for the *Statesboro Herald*. On September 21, 2007, he related "A Ghost Story from Brooklet." Just east of that community off U.S. 80 and Railroad Bed Road is Robertson Road, a seven-mile-long dirt lane that for decades was the roadbed for the Savannah & Statesboro Railroad, in a locale occupied by farms and pasture. When this route was part of the Savannah & Southern Railroad system, Allen wrote, an equipment breakdown caused a train to stop along this stretch of rail.

The switchman jumped down to the right of way and started walking toward the engine, inspecting the train as he went. Something, perhaps loose ballast rocks, caused him to lose his balance, and he fell between the engines pulling the train. Unaware of this, the engineer engaged the throttle, and the locomotive and the train moved forward, decapitating the rail employee. Unaware of the tragedy, the train continued to its destination, where the switchman was discovered missing.

A search along the tracks discovered the switchman's body, but his head was never found, or so the story goes. Decades passed, the rails were removed and the route became a rough dirt road. Local motorists soon observed "a series of floating lights," usually yellow or orange in color, that appeared above the center of the road. The lights, sometimes bright enough to be seen several miles away at the village of Grimshaw, are most often witnessed in the warm early weeks of autumn, in early morning fog following a late-night rain.

A number of rail employees and passengers were killed in train wrecks, and workers often encounter ghosts on their nocturnal routes. *Jim Miles.*

At times, Allen wrote, people "have witnessed a black man underneath the lights taking shovelfuls of dirt and tossing it across the road," particularly beside an old cemetery. The idea is that he worked at a cotton plantation here and was forced to excavate his own grave. Other embellishments incorporate sightings of ghost dogs and "ghostly horses pulling what appear

to be chariots…an entire ghostly zoo full of all kinds of creatures with even cages discernable in the lights."

Another story is that an older man was hunting in the area and died of an accidental gunshot. On the Ghosts of America website, Sadie said it was her grandfather—"he is just trying to let others know that he is still there and does not want to be forgotten."

For several generations, cars conveyed curious people, particularly students from nearby Georgia Southern University, to the road late at night, all seeking a glimpse of the supernatural. Even churches incorporated the mystery into their programs. A festival for youth began with adults spinning tales of the purported paranormal events, followed by a hayride to the haunted locale. Local residents often cling to their tales of the macabre.

A woman named Cody and her boyfriend drove down Ghost Road one night, as she wrote on Ghosts of America, and doused both ignition and headlights. Within two minutes, a lantern-like light floated along one side of the road, slipping into a ditch and then reemerging. One minute later, a bright light approached from the rear. They cranked up and sped away, but the light "got closer and brighter, then disappeared."

During the encounter, they felt "this strange energy." Intrigued, they stopped again and challenged the phenomenon to return, which it did with a vengeance. "It looked like something tried to pull him out of the window," she said of the boyfriend, who understandably freaked out.

They drove away quickly again but "heard a loud rumbling sound on the hood of the car…like a train was passing," That was followed by a rustling from nearby bushes, "and we saw a dark hooded figure, looked sort of like the grim reaper, flying next to our car," but it failed to overtake them.

A woman named Kimberly and a friend were on the road one night at 1:00 a.m. when the light approached. As it reached a distance of twenty feet, Kimberly attempted to crank up, but the car wouldn't start, her headlights failed and her windows suddenly fogged up. When the mist cleared, the car started and they sped away.

A man named Hunter claimed that after he and his friends stopped on the road late one evening, the windows fogged. The lantern light appeared in the distance, but "we saw a man in a trench coat start walking towards the car with the lantern," at which point they boogied for home.

Burke County

SHADOW GHOST BOY

According to his account on the Ghosts of America website, Juice saw his first ghost in 1990, when he was five years old. At the time, he lived in Waynesboro Gardens, which his stepfather said was once a graveyard, perhaps for slaves. Juice shared a bedroom with two sisters and slept on the top level of a bunk bed.

One night, his mother had just turned off the television and put the children to bed, but Juice wasn't tired and needed to use the restroom. He climbed down from his bed and started for the bathroom, located directly across from his parents' bedroom and next to a utility closet. "The house was dark and I was already scared," Juice wrote. He hurriedly finished his business and climbed back into bed, "and that's when I saw a small figure of a boy in black run right into our utility closet. I was scared, I wouldn't sleep. I told my mom what I saw and she beat me for lying."

Juice could distinguish no details, but it "looked like a shadow of a little boy, kind of only a figure. You could tell it was a little boy." However, "a few nights later," he continued, "my stepfather saw it, he thought it was one of us going into the utility closet."

Although Juice has never since saw the shadow boy, on occasion, "I wonder if I'll ever see him again." He also maintains, "I wasn't lying and my mom beat me for nothing."

BUTTS COUNTY

MISS MARY RETURNS TO ROCK CASTLE

In the January 1985 issue of *FATE* magazine, Minerva Torbett told a story titled "The Ghost of Miss Mary."

The incident occurred at Indian Springs, a site of many mineral springs once considered medicinal. To this day, residents descend on Indian Springs State Park with empty gallon jugs, which they fill from the springs, now protected by a substantial stone building. Many still believe in the healing powers of these waters.

Native Americans coveted the site, hence the name, and it became a major vacation spot during the golden days of spring resorts. A number of great hotels and grand homes were constructed around the famed springs, but in time, each fell victim to fire or demolition.

One of the last of the grand structures to survive was Rock Castle, constructed in 1853. During the 1930s, Torbett wrote, Rock Castle was occupied by two elderly sisters, Miss Carrie Collier and Miss Lou Collier, and their niece, Miss Mary Cleveland.

These three women loved the young people of the community and established a children's library in their living room. Kids were encouraged to check out and read as many books as they could. Torbett and her friend Evelyn Archer frequented the library and "learned to read before we entered first grade because of the Children's Library," Torbett wrote. The ladies also taught young people about the natural world around them.

During the girl's third-grade year, a flu epidemic struck Indian Springs. Miss Mary got sick and died, while Miss Lou was bedridden and Miss Carrie

During the 1930s, girls saw the spirit of a dead woman on the stairs of Rock Castle at Indian Springs. *Author's personal collection.*

became ill but was still ambulatory. Evelyn's mother told her daughter and Minerva that they "should go to see Miss Lou," although they were "cautioned...not to stay too long and to be on our best behavior."

A maid answered the front door and sent the girls up a beautiful curving staircase to visit with the sisters. "There we stood beside Miss Lou's bed holding her hands while we talked with Miss Carrie," Torbett wrote. "In a short time we said our goodbyes to both ladies and started down the dimming stairway."

The young ladies were horrified to see Miss Mary ascending the stairs toward them. "I seemed to be able to see through her upper torso but there was no mistaking her face surrounded by the white pompadour of her hair. Evelyn and I rushed for the front door; we actually fell down the front steps, got up, and ran as fast as possible to the sandbar in the small creek that cuts through the park."

After Minerva and Evelyn caught their breath, they found that they had identical accounts of what they had witnessed. Miss Lou died several days later, followed by Miss Carrie. "It was a sad time," Torbett concluded.

Rock Castle was abandoned during the 1950s or 1960s. It stood as a shell for years until it eventually collapsed.

CANDLER COUNTY

THE HOTEL REVIEW GHOST

In the fall of 2012, a woman and her two daughters left Savannah to return home to Tennessee. It was late at night, and the tired mother decided to stop for the night at a Days Inn hotel in Metter. The establishment looked comfortable, and even though she thought the price was a little steep, she found the room "very clean and [it] felt very welcoming," she wrote on daysinn.com in an entry titled "The Ghost in Room 102." However, she was disappointed that the room lacked a refrigerator and microwave, and her children complained about the lack of WiFi. There were other problems, and the hotel review the woman submitted on November 19, 2012, contained a litany of faults.

"The heater smelled really bad when we first turned it on, and our neighbors slammed the door many times before they finally went to bed. The water in the bathtub was leaking & the light above the nightstand wasn't plugged in but I didn't feel like having to move the table. But, all that aside, we went to sleep."

That was when the hotel review took a bizarre turn:

> *I was then awakened feeling that someone was staring at me, and saw what I thought was my daughter standing in front of the sink/mirror—but when I shined my cell phone light into the other bed, I saw their two heads on their pillows. So, when I shined the light into the area of the sink/mirror, there was nothing there. I just shrugged it off, and rolled back over. When we finally woke, I remembered what I had seen in the night, but I didn't*

Guests at this hotel in Metter had feelings of being watched and saw an unknown figure lurking in their room. *Earline Miles.*

want to scare the girls, so I just tried to get them in the car so we could be on our way. Still, Brittany said she felt someone watching her last night, and Alicia then said, "I thought I saw someone in the room." Keep in mind I hadn't said anything to them about what I saw. Needless to say, I then told my story and we got out of there faster than we have ever exited a hotel in our lives!

CHATTAHOOCHEE COUNTY

GENERATIONS

Carly was an eleven-year-old resident of Cusseta, the latest generation of a family who had lived there for more than two hundred years. Her house had been constructed by her ancestors in the early 1800s. In the backyard, where "I find extraordinary stuff," she wrote on Ghosts of America, she found a Confederate button from a four-and-a-half-foot hole her dog had dug. Chillingly, that site turned out to be the grave of a great-great-great-uncle, and his spirit might have been loosed.

One night, Carly was alone in the house with a friend while her parents were running errands in nearby Columbus and her brother was at his job.

Cemeteries across Georgia contain the remains of Confederate soldiers killed during the Civil War. Ghosts are often encountered at these sobering places. *Earline Miles.*

The two girls were sitting in her bedroom making bracelets when "the TV turned on in our living room." Finding that odd, Carly entered the living room to investigate. There, she reported, "I could have sworn I saw a figure walk into my parents' bedroom."

Carly dismissed the incident as fatigue. Later in the evening, at about 8:30 p.m., Carly and her friend were hungry and went to make soup in the kitchen. "When I went into my parents' bathroom I saw the same figure I had seen earlier staring back at me, startled. I screamed....He then disappeared into thin air."

Carly thought the figure seemed familiar. The following day, she was poring over family photos that dated back well over a century. She spotted her ghost in an old picture of the house and was informed that he "was my uncle that had died during the Civil War."

COLUMBIA COUNTY

THE ANGRY GHOSTS

Ihave conducted extensive research in the realm of the supernatural. This is one of the most frightening encounters I have discovered. The story appeared in the October–November 1998 issue of *Augusta* magazine, in an article, "Horror Is a State of Mind," written by Nancy Bowers.

In the early 1980s, Lisa and her husband were busy creating their dream home. They purchased a seven-thousand-square-foot, four-floor, Dutch Colonial mansion constructed in the early twentieth century by H.T.E. Wendell, a famous Augusta architect. The massive structure was moved from Augusta to Columbia County, where the couple owned fifty acres of rolling hills covered in timber, two-hundred-year-old oaks and massive granite outcrops, all of which created a stunning scenic setting. This would be the place where they raised their children and spent their later years. The dream, however, quickly turned sour.

"There's something horribly wrong about that place," Lisa told Bowers. "You couldn't pay me to go back inside. I just want to close that chapter of my life. It was a nightmare."

The family had been in residence in the house only a few days and had not brought in much furniture. The room directly above Lisa's bedroom was empty except for a large trunk that once belonged to Lisa's grandmother. One night, the couple woke to what sounded like the massive trunk being repeatedly dragged across the floor. On that occasion, they crept upstairs to investigate but found nothing wrong. The room was secure, and that trunk was where they had left it. Lisa returned

to the bedroom, and her husband dragged the trunk across the floor. The sound was identical.

"It really weirded us out," Lisa admitted. "We knew something extraordinary was going on inside that house, but just what that was, we didn't have a clue."

The phantoms varied their routine, adding strange laughter and slamming doors, and ponderous footsteps were often heard. Several nights after the incident with the trunk, Lisa and her daughter, age two and a half, were alone when additional banging originated from overhead.

"It sounded like footsteps," Lisa swore. "Angry footsteps, walking quickly and in anger. Doors were slamming everywhere. Whoever or whatever it was would take a few steps, slam another door, then go on to the next room, all over the upstairs. The only thing is, the house was being renovated at the time, and there weren't any doors up there in that part of the house." Lisa thought the presence seemed enraged. After twenty minutes of terror, Lisa picked up the girl, and they abandoned the house.

The climax occurred several weeks later as Lisa and her daughter were walking down the hall from the girl's nursery to her bedroom. "Mommy," the child asked, "who are all these people who keep talking to me?" Lisa quietly explained that they were alone, but the girl responded, "No, Mommy," and pointed behind them. "I mean those statues behind us that look like people." Lisa picked the girl up and ran from the house, which was for sale the following day.

CRAWFORD COUNTY

GHOSTS OF TWO COUNTY BUILDINGS

In October 2007, the Georgia Ghost Society (GGS) descended on two old county buildings: Crawford County's 1852 courthouse in Knoxville, one of the oldest surviving in Georgia, and the old jail located a short distance away, which closed in the 1970s. These investigations were extensively covered in Middle Georgia media.

Macon resident Bob Hunnicutt, founder and director of GGS, has extensive experience in the field of paranormal investigation, starting at age seventeen. "I've been slapped, had my legs knocked out from under me and I've been physically grabbed," Hunnicutt told the *Macon Telegraph*. "Anyone who does this and says they're not scared is either a liar or a fool."

The GGS was called in because of reported paranormal activity in the courthouse. "We've had a couple of people with us that have had experiences in here like a cold spot," Hunnicutt said. "One of them had a battery-operated lantern that would go completely off when she went across the threshold upstairs." That threshold leads into the courtroom, where Drew Hester, co-director of the GGS, who has led ghost tours, had her own odd experience.

"It was a feeling of fear," she said, "not me being scared, but again, almost a residual energy left behind that you kind of step into and your brain and your senses kind of match up with it and you feel it." She believes the residual energy there was deposited by generations of defendants entering the courthouse to face their fates. Hester likens the sensation to being on a roller coaster, when "you start to go down and your heart kind of goes—it's not a scared feeling, but it's kind of an adrenaline rush."

Paranormal investigators in Crawford County's old courthouse and jail reported being touched, tugged and shaken. *Earline Miles.*

The GGS team also set up its equipment in the old Crawford County Jail. During that investigation, GGS member LeAnne Boggs of Covington, who is psychic, felt someone touch her while she lay on a cot within a metal cell. "There was no explanation for that," she said. "It felt like someone was touching to wake me up, like grab your leg and shake a little." Her partner, occupying a cot in the same cell, also felt someone tugging on him.

During an earlier investigation in the jail, a voice recorder captured the sound of jangling keys, and on this night, members also heard keys jingling outside the cell and unexplainable knocks upstairs. "I think it was more residual," Boggs said. "Just kind of an impression left in the location, if that makes any sense. It's just an energy. I personally don't feel any ghost spirits active here."

An EVP session apparently energized the resident spirits, for Kim Gordon described her experience in the jail: "I was standing in the cell on the bottom floor…and the hair on the back of my neck stood up…and then the hair on my left arm stood up…and then someone poked me in my left side."

"I think what everybody heard and experienced was during an EVP session," Hunnicutt said. "Things were pretty controlled tonight with very few exceptions. I think what we heard was generated through a paranormal or supernatural source."

DOOLY COUNTY

FLINT RIVER HOODED SHADOW

One summer, when "Lcturnel3" was sixteen, as he wrote on yourghoststories.com, his family spent weekends in their camper at a campground near Vienna, just off the Flint River. "It was a lot of fun to me because there were kids my age there and we could come and go as we pleased," he related.

Late one night, his friend Josh, who lived nearby, texted to ask if he were awake and wanted to ride around rural dirt roads in his new pickup truck, "a huge lifted" vehicle that rode on thirty-seven-inch wheels.

Lcturnel3 was just watching TV and sent an affirmative reply. He walked to the end of the campground to meet Josh because the truck was so loud it would have awakened the entire compound. They rode a few miles on back roads but grew paranoid that law enforcement would be out enforcing the curfew at 3:00 a.m.

The boys parked in front of the camp store and talked about girls (they were sixteen, after all). As they sat conversing in the cab, "the whole back end of the truck just dropped down and back up real fast. Almost like someone jumped on the bumper."

Startled, they quickly looked about the deserted, well-lit area and "couldn't even believe what we saw. There was a very dark figure at the back of the truck. It looked like [it was] standing on the bumper, but...didn't come up very high over the tailgate." They estimated the height of the being to be four feet. The oddest part, to the young men, was that this figure was hooded, and they could not discern a face or any other features—"just an outline. Kind of hefty, but not huge or thin."

Actual angel sightings are reported across Georgia, and cemeteries are dotted with representations of the figures. *Earline Miles.*

Josh bolted from the cab to confront the apparition, while Lcturnel3 scanned the area from the safety of the vehicle. When Josh returned, Lcturnel3 "asked him what he saw because he looked terrified! He said he didn't see anything. (I think that's what scared him the most.)" Lcturnel3 added that Josh "isn't afraid of anything so to see him so scared really freaked me out."

Both thought a man could not have moved fast enough to escape their scrutiny in the parking lot. Lcturnel3 wondered if "it was just a ghost having a little fun scaring two kids who should've been home at that hour." The boys barely spoke of the incident and told few others about it. It took Lcturnel3 six years before he would share the story online.

EFFINGHAM COUNTY

THE SPIRIT IN BOB'S ROOM

Upon learning that their friend Bob was dying, a couple residing in Guyton kindly invited him to spend his remaining days with them. Bob was put up in the sunroom, a space off the primary living area, which became known as "Bob's room." After he quietly died, the house experienced a number of paranormal episodes.

The father saw an apparition in the hall and heard footsteps coming from Bob's room, and the door to that area also opened without cause. A young son witnessed the ghost of a small boy in his parents' bedroom, saw shadows in his own room and heard noises emanating from the attic. He was unable to sleep in his room, and the stress of living with the supernatural was causing him to become physically ill. The mother observed strange lights in the house and doors that unexpectedly opened during the night. Once, when a door opened, the family's dogs became agitated and started barking at an invisible intruder.

The parents decided to have the house investigated, and the father called the Northeast Florida Paranormal Investigators (NEFLPI) for a survey of the house. The resident spirit apparently did not endorse the idea, for after the ghost hunters were called in, the center of their computer screen was damaged by a force that exerted great pressure. It appeared that the screen had been "punched," as with a fist.

One night, the family vacated their home for a hotel, and three members of the NEFLPI—John, Renee and Aug—spent five hours in the house. They discovered little of a supernatural nature but did record some

"interesting EVPs." They concluded that the entity was not harmful. The parents did not want the spirit, perhaps that of their dear friend, to be "cleansed" and decided to find a method of helping their son deal with his fears.

EMANUEL COUNTY

LOVE TRUMPS GHOSTS

"The old Hall place was said to be haunted," Ronnie Johnson wrote in the Swainsboro *Forest Blade* on June 17, 2013. The abandoned structure was just across a small stream from Johnson's boyhood home, strangled with vines but still occupied by black cats that hissed from the front porch. In the evening, his family sat on their front porch, looking at the old house, telling stories and speculating.

Johnson's father described tragic events connected with the old Hall place: "A little girl had disappeared one cold, winter night and was never seen again," the son wrote. "Bloodhounds were called in, and her last steps were to a bridge below her house. The next year, the family moved away and was never heard from again."

The elder Johnson had to walk past the house to court his future wife. Sometimes his father would loan him the farm truck, but mostly he had to walk past the structure to see his girl, and on the return journey, it was later, darker and spookier. "He said when the wind was blowing and the moon was full, your mind played tricks on you."

But love conquers all, including fear of the supernatural. "He said his skin felt like a charge of static electricity branching off from his spine. His heart was beating so fast that he didn't know whether to slow down or take off running....'If I hadn't been head over heels in love with your mother, I would never have approached the Hall place,'" Daddy declared.

As Ronnie's father strode quickly by the old dwelling, shadows "cast strange images all around" that house. "I actually thought I saw a headless

woman standing near the old smoke house. I froze in my tracks." Johnson explained that back in those times, many believed in ghosts and haunted houses. His father's route back home was not illuminated by electrical lights, and country roads were dark, illuminated only by the moon and stars. Of course, there were many moonless nights, and cloudy skies made things even scarier.

Daddy's "imagination would often run wild," but he never knew if he ever "saw an actual ghost because he never took the time to be certain." As the elder Johnson would tell his children, "I could turn on the jets when I neared the old Hall place. I had to outrun those ghosts."

GLASCOCK COUNTY

THE DEAD LADY SPEAKS

From the grave, a mother in Glascock County chose the woman she wanted to raise her baby. *Earline Miles.*

This story was recorded by the students of English professor John A. Burrison of Georgia State University and was included in *Storytellers: Folktales and Legends from the South*. In the spring of 1979, Pamela Roberts recorded the tale, titled "The Dead Lady," from sixty-year-old Hattie Mae Dawson, of Gibson, who heard it from her grandmother, a resident of rural Glascock County.

A woman delivered a baby, but the ordeal left her gravely ill. Knowing that she was dying, the woman wanted her wishes known as to who would raise the child. She had no sisters, but a number of brothers, and she called in one sister-in-law, Ruth, and told her, "When I'm gone, I want you ta have my baby. I don' want Lou ta have it; I want you ta have it."

After the mother died, her sister-in-law Lou boldly stated, "I don' care what y'all say. I'm goin' take that baby. An' I'm goin' raise it, 'cause that's a purty baby."

Following the funeral, the family returned to the woman's house to launder all the curtains and bedclothes and wash down all the walls and floors, as was the custom. Afterward, the family gathered beneath a tree to relax. "An' Miz Lou had the baby in her lap. An' every'body jes' sittin'

there laughin, an' talkin'. An' somethin' come down an' took that baby outta Miz Lou's lap an' put it in Ruther's lap!"

This supernatural event frightened all present and caused most to run fast and far, but the point had been made, because "they know, then, who that lady wanted to have that baby," the story concluded.

New and old copies of *Storytellers: Folktales and Legends from the South*, both hardback and softback, are readily available online.

GREENE COUNTY

THE GHOSTS OF EARLY HILL

In 1959, Roger and Carlene McCommons bought a large antebellum house, located three miles north of Greensboro on Lick Skillet Road, as well as twenty-three acres of forest and pasture. The structure, built in 1825–30 by Joel Early, brother of Georgia governor Peter Early, who served between 1813 and 1815, was once the center of an eleven-thousand-acre cotton plantation. The hilltop house, in the Georgian style, had been unoccupied for twenty years and was used for the storage of hay. The house was not wired for electricity, there was no modern plumbing and heat was supplied by ten fireplaces. Roger, called "Deeta," a postal employee and skilled carpenter, and his family replaced the old windows, installed modern plumbing and lived there for nineteen years, from 1960 to 1979.

Extensive renovations carried out by the McCommonses were initially met with displeasure from the resident spirits. "It was messy and plaster was piled on the floors," school librarian Carlene told Charles Salter of the *Atlanta Journal Constitution* in July 1987. "It was awful. We got a feeling of oppression being in the air. It was kind of like somebody didn't like you and what you were doing to the house. Once it started shaping up and the house was looking better, that feeling of oppression would go. Then we had a great feeling."

The McCommonses' children often reported strange noises, which were dismissed as normal sounds and young minds. However, the family was soon observing a small family of ghosts. The youngest son saw a young boy in the upstairs attic. Son Roger heard the sounds of a girl crying in the house.

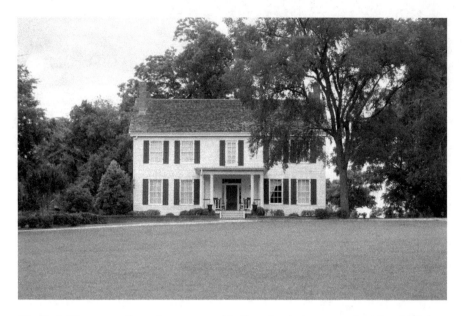

The Early House near Greensboro was psychically active during renovations, but the haints settled down. *Earline Miles.*

One day, Roger adamantly refused to go upstairs because there was a little boy up there. A psychic would state that she had heard a girl crying in the same area.

Daughter Rosalyn ventured to the attic for a doll and was frightened by the footsteps of something pacing behind her. She stopped walking, but the phantom steps continued. She observed a more foreboding figure as she studied upstairs. "She reached up to turn on the lamp," Carlene said, "and looked in her room and saw someone who looked like Daniel Boone wearing rawhide with a long gun in his lap, sitting in the chair." One day, Rosalyn heard and saw the girl.

Early one morning, a nephew camped in the front yard with one of the children watched an elderly man in a nineteenth-century suit sitting in a rocking chair on the front porch.

Many nights, the family was woken by footsteps in the attic and on the stairs. They named one of their nocturnal visitors "Old Peg Leg." Also heard from the stairs were rattling chains, which local lore claimed were slaves being punished.

Carlene thought little of the stories until one morning, after she had gotten the children off to school. She was making a bed upstairs when she

spotted, through a mirror reflection, the girl walking down the hall. "What I saw in the mirror was this little girl tiptoeing down the hall," she said. "I saw the back of her head. She had curls in her brown hair and wore a pink chiffon-looking thing. I went into the hall and then into every upstairs room. I couldn't find anybody. I thought this is the craziest thing I ever heard of. I went downstairs and she wasn't there. She certainly was big enough for me to find her."

The expertise of a local psychic was sought. She found that a young girl had fallen from a swing in an adjacent pasture and died. Fifteen years earlier, the McCommonses had chopped up a fallen tree for firewood and noticed that two chains had been attached to one limb, which perhaps had supported the swing.

While living in the Early home, the McCommonses constructed a home on nearby Lake Oconee. They decided to take part of the older house with them—two doors, one to the second-floor attic and a second to a storage area beneath the stairs. "They are well-hung and fastened," Carlene told Nancy Roberts for her book *Haunted Houses: Tales from 30 American Homes*, "but on occasion they pop open, and no latch will hold them." Both doors would suddenly spring open for no reason, dozens of times by both day and night, without any human interaction.

The door ghosts were not the only haunts that made the move. As the second floor was started on their lake house, Carlene and her husband stood in the front yard and took pictures of the construction. One of the developed pictures showed a young person looking over a board and out an opening on the second floor. "You can see her here in the picture," Carlene said. "It looks like a little girl. Deeta and I didn't recognize her. At that time there was no flooring up there and no stairs or ladder. A child couldn't have climbed up there."

The Early house spirits kept on ghosting long after the McCommonses left. By 1987, the home was owned by Leonard Shockley and was being renovated as a bed-and-breakfast by his son, Kevin, and several local men. Kevin joked that "we won't charge extra for the ghosts. We're fixing up things nice and want the ghosts to be happy. My sister was reading in a bedroom and she saw a small figure like a little girl in a white dress walk by the door. [One] story is that a man with a peg leg fell on the stairs and died. The ghosts add more mystery to the house." The bed-and-breakfast no longer operates.

In "Haunted Hot Spots," an article by Kristi Hall in a fall 2008 edition of *Lakelife* magazine, Greensboro historian Joel McRay said, "It has also

been mentioned that you can see strange reflections in the mirrors, like the girl getting her hair brushed by her mother. There have also been times when the vision of an elderly woman has been seen rocking on the front porch. As soon as you approach the steps, she disappears and the chair continues to rock."

Various editions of *Haunted Houses: Tales from 30 American Homes* are available online.

HANCOCK COUNTY

THE GHOSTS OF SAMANDKA

Olive Ann Burns is a notable name in Georgia literature, famed for her novel *Cold Sassy Tree* and its unfinished sequel, *Leaving Cold Sassy*, published posthumously. She was also a feature writer for the late and lamented *Atlanta Journal Constitution Sunday Magazine*. On November 11, 1973, the magazine published her piece "The Ghosts of Samandka Make a Lot of Noise."

In 1945, Katherine and Sam Hollis purchased a 1786 house outside Sparta, in Hancock County, and named their homestead Samandka (a combination of their names). The first three months were quiet, but one Sunday after they had placed daughter Sarah in her antique cradle and retired to a porch, they heard a thunderous "BAM!!" from the infant's room, followed by "a sound like all the glass in the world breaking and splintering," Katherine told Burns. They raced inside to find Sarah quietly sleeping. No windows were broken in her room; indeed, nothing was wrong anywhere in the house.

Katherine raised four children and managed the ever-growing house as portions of two other historic Hancock County buildings were grafted onto theirs, while Sam became president of the Bank of Hancock County. Katherine believed that the ghosts native to their home were joined by spirits from the other dwellings, although she believed that each stayed in its respective places.

"After that first scare we had weird noises hot and heavy for about three years," Katherine stated. On one occasion, her sister's children were present

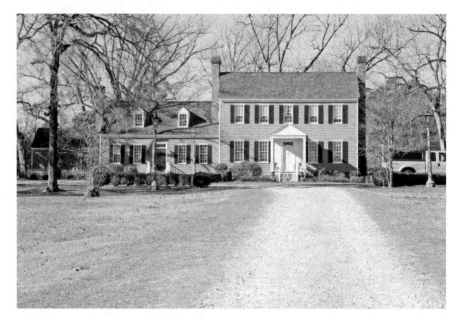

When a Hancock County family joined three historic houses together, ghosts from each created an extraordinarily active paranormal playground. *Earline Miles*.

when they heard the sound of dragging chains and stealthy footsteps in the dining room. They looked in the room several times, but the noises continued, and the women and children were so unnerved that they walked down their dirt road to the highway to await Sam's return.

Katherine stated that her worst scare had occurred a year earlier when her feline, Puddy Cat, and Babee, her toy poodle, both apparently saw an entity. The cat "was near the stairs when suddenly, with eyes fixed on something at the head of the stairs, she arched her back and fluffed her tail, ready to fight. She started screaming, in unearthly yowls, and ran back to the kitchen where I was, and then flew off in terror to hide somewhere. What she saw must have been horrible."

She continued: "Babee heard the commotion and started up the stairs yipping and growling. She'd run back to me, then back to the stairs—growling—but suddenly she started wagging her tail! Whatever or whoever it was, Babee had recognized somebody she felt was a friend." Katherine had feared it was a human intruder, although no other living person was present.

Katherine accepted the ghosts because "I am convinced the ghosts aren't out to harm me." However, when a presence appeared in a room, she got "a sort of shivery feeling in the hair follicles."

In early January 1972, poltergeist activity started. Katherine had left a silver tray filled with champagne glasses on the kitchen counter since Christmas. One day, she was getting something out of the refrigerator while daughter Carol worked at the stove when the glasses seemed to leap off the counter and shattered on the floor.

That October, Katherine and her visiting cousin, Sara Frances Heath (Sada Fan), were cleaning the kitchen after lunch when "we both felt compelled to look up toward a half-open cabinet on the other side of the kitchen," Sada Fan wrote, "just in time to see a glass sherbet dish come sailing out of that cabinet and fly through the air toward us."

The dish did not fall, she explained. "It sailed in an arch and landed eight feet or more from the cabinet—less than two feet from us! It didn't break—just bounced twice, hit the refrigerator, and spun round and round."

The women and Sada Fan's husband, Sherwin Heath, felt a presence that compelled them to leave the room. Katherine was shaken because, although she had heard many strange things in the house, she had never *seen* any phenomenon, and it was not finished with this phase of its manifestation. "When we sat down to eat that night," Sada Fan continued, "we heard silver being rattled in the kitchen drawers—heard it twice and suddenly a vacant chair at the table between Katherine and me JUST LIFTED UP AND MOVED ABOUT TWO INCHES TOWARD THE TABLE!" The women were unable to eat or sleep that night.

Katherine's husband, Sam, admitted to hearing the initial "BAM" noise and experienced the same sound several years later in the same room, but generally he denied knowledge of other phenomena. However, Katherine insisted that he did experience much of the other paranormal activity.

Katherine and Sam heard tinkling chains that walked across their bedroom floor. "It's a sound like a necklace with tiny delicate links that slowly fall, dropping over and over," Katherine related.

They also heard "footsteps and crashes and sighs and bangs. What really got us was the night we were awakened by a loud thud, *thud*, THUD. It was exactly like somebody falling down the stairs hitting every step." They feared a child had tumbled down the stairs, but all were safely asleep.

Sam's mother, Miss Carrie, had gone to bed early while the rest of the family settled into an adjoining sitting room. Suddenly, the sound of a wooden bowling ball was heard rolling across the bedroom and bouncing off a wall by the bed. "Sam's mom was frightened and upset," Katherine said, and became an instant believer. On another occasion, Miss Carrie was shoved by a phantom in a room where Sam kept his hunting guns.

Some rural communities continue to thrive, while others are largely abandoned. One thing that often remains are the spirits of their past. *Jim Miles.*

For many years, the front door was warped. To open and close it required a simultaneous pushing and lifting of the door. It would not open or close without considerable effort. One January night, Sam had closed and locked the door and gone to bed when they heard the door closing and the latch engage. "THEY HAD NOT HEARD IT DRAG OPEN," Burns emphasized.

The Brookins-Mullally House, built in 1812, provided a parlor to their home, while the 1820 Cooper House, a wayside inn once located in Powellton, contributed several rooms. There were traditions associated with the Cooper House. An entire family had died of poisoning in the eighteenth century, and around the end of the Civil War, a resident, responding to a drunk and threatening man, blew the man's head off.

An elderly resident of the property was in his yard one night, "carrying a light'ard knot torch and a headless man passed him on the road in front of the house," Katherine said. The headless ghost was also witnessed by his wife, Mary. "She was sitting outside about dusk and watched a headless man walk through the yard."

The derelict Brookins-Mullally House had been ravaged by vandals except for one bedroom, where Berta Webb died delivering her twelfth child, and Katherine thought, "maybe something happened to make [the family] afraid to go in."

Berta's mother, Beadie, helped care for Sam and Katherine's children before her death. "So when unseen hands opened a jelly glass for me last week, I had the feeling they were Beadie's hands." Katherine hated opening jelly glasses—they always stuck, and she usually broke fingernails at the chore. One morning, she had set out a jelly glass on the counter and turned to the stove where bacon was frying. "Then suddenly that jar top popped off and fell very gently on the counter. All by itself."

One night, Katherine was entertaining Elizabeth Hight Alexander and her nephew, Jim Hight, with ghost stories. She explained that when her daughter, Sarah, was four, she said, "Mama, I saw some white shoes walking last night, but nobody was in them!"

Elizabeth, an unbeliever, suddenly announced, to Katherine's horror, "IF THERE'S A GHOST IN THIS HOUSE, MAKE YOUR PRESENCE KNOWN!" That very moment, a resounding "BAM" was heard from behind the fireplace, and a little brass teakettle was pushed off a mantel and fell to the floor "by unseen hands"; the handle broke.

Daughter Caroline's room was located in the Cooper House/wayside inn, which Katherine said "is the spookiest place we've got. You're very apt to feel a presence up here." She told Burns, "I feel something right now. Do you? A presence, I mean, a feeling there's somebody here I can't see."

Several years earlier, Caroline was a student at Wesleyan College in Macon and had returned for a weekend visit. As she sat at the dressing table rolling her hair, "she saw in the mirror a gray-haired old woman lying on the bed, arms crossed," the pose implying that she was dead. Caroline whirled around, but "NO ONE WAS THERE," Katherine said. Caroline told her, "Mama there was a DENT in the pillow!"

On a different occasion, Caroline "woke up and saw THAT SAME LADY, standing against the wall with her arms crossed!"

One weekend, Carolina brought her fiancé, Jim, home, and he stayed in that same room. The family had not revealed their ghost stories, and likewise Jim was reticent about his experiences there. On the drive back to Macon, he told Caroline, "I woke up feeling as if I were surrounded by cold air—and suspended in it about a foot above the bed!"

In the library, also fashioned from the inn, Katherine had heard moaning and sighing. "Weary-traveler type groans," she said, "out of the stagecoach inn I suppose."

As stated in the introduction to this book, sometimes the best ghost stories originate from rural areas of Georgia.

HARRIS COUNTY

THE ADAMS FAMILY LIVE IN A HAUNTED HOUSE

The Stagecoach Inn, constructed in 1824 in Waverly Hall, may be the oldest building in Harris County. The original structure consisted of two two-story log cabins with an open passage between to accommodate coaches. The bottom floor of one had a parlor on the first floor, with sleeping quarters for women on the second. The other cabin had a kitchen on the first level, with sleeping quarters for men above. The driveway was later enclosed as a dorm for boys. Still later, a kitchen, dining room and double-sided fireplace were added. The original log construction is still visible upstairs, and many features of the inn remain.

One creepy legend of the Stagecoach Inn relates to the old well located behind the house. Stories persist that during the Civil War, a Union soldier either fell into that well and drowned accidentally or was murdered and the body thrown down the well to cover up the crime.

In 1995, the house was purchased by Pam and Jimmy Adams. In 2003, a daughter, Sarah, reported that no paranormal activity had occurred in the house, although one of her friends refused to venture upstairs. Later, the ghosts began to assert themselves.

On August 15, 2009, a three-person team from Effigy Paranormal, accompanied by Taylor Barnhill, of Columbus TV station WTVM, arrived to investigate the home's haunts. As time had passed, the Adams family "have reported some strange occurrences," Barnhill reported. Specifically, Jimmy Adams said, "My wife said that she has occasionally felt something behind her. In one particular instance the mailman came up and he made a

comment that he saw someone behind her in the house when there wasn't anyone here but her. And we've had a friend over who has said he has seen something out in the hallway."

The Effigy group was led by Judy LaChance, its founder and director. She explained that the team would arrive early to interview the family, make a daylight tour of the structure, take base readings and photographs by daylight and then "turn out the lights and go in every room and kind of get a feel and do some readings and get some EVP. Our specialty really is EVP."

LaChance's years of research had produced little photographic or video evidence of hauntings, but she has found far more evidence with EVPs. The team made use of a video recorder, a digital camera, an EMF detector, a digital thermometer and a digital voice recorder. A new member, Tina Rexach, was also a medium and would provide most of the night's experiences.

EMF spikes were detected at the downstairs bedroom, the front door and the old well, where the temperature dropped seven degrees. "A figure was reported by our medium moving into doorway" of the men's upstairs bedroom, the Effigy report read, "towards bed and back out."

On the upstairs landing, "A loud gruff voice stated one inaudible word. Heard all present [Judy, Kathy Mills, Tina]."

The most paranormally active part of the house was the downstairs dining room and kitchen, where "Tina sighted a man dressed in period clothing on the stairs. This man was later sighted by Tina in the dining room as well [and] a tall man was also sighted standing in the doorway to the foyer, leaning against the door frame. This was witnessed by Pam, Tina and Taylor. Judy had the sensation of her right ankle being shackled and heard what sounded like a recording being played backwards [is Paul still dead?]. An EVP was recorded at this time. Kathy sighted an odd light on the staircase."

The EVP ominously said, "Don't want you in my house."

These results make one wonder if perhaps the ghost of the reported Union soldier from the well was making its presence known.

HEARD COUNTY

THE AFTERLIFE OF MAYHAYLEY LANCASTER

Mayhayley Lancaster proudly claimed to have psychic powers, saying that she was "an oracle for the ages." The fortuneteller read palms or performed trance rituals that put her in contact with the spirit world, she explained. Mayhayley helped people locate lost or stolen property, predicted the sex of babies, determined who someone would marry and provided gamblers with winning lottery numbers. Thousands of seekers arrived from several states, and few went away without the answer they were seeking. Lancaster also provided key testimony in a famous murder trial that resulted in a man's conviction and execution (See *Weird Georgia*, Cumberland House, 2000).

Lancaster died at age seventy-nine on May 22, 1955, and was buried at Caney Head Methodist Church in Heard County, near Roosterville. Bizarre legends have followed Mayhayley in death. She would be irritated to learn that she is now popularly remembered as being a mean-spirited witch who curses people from the grave.

Although dead half a century, Mayhayley apparently believes that she still deserves compensation for her services. "NinjaCthulhu" wrote online that if someone wanted a response from Mayhayley today, they should leave all their pocket change at her grave. "Worked for my husband," she wrote. "His wedding ring was missing for weeks. I finally talked him into visiting her grave and leaving his change for her…he found his ring the next day." She also revealed that her granddaughter was buried there, specifically "so Ms. Mayhayley can watch over her."

Georgia's most accomplished fortuneteller, Mayhayley Lancaster of Heard County, testified in a death penalty case. The convicted man was executed. *Heard County Historical Society.*

Lancaster's grave is usually covered with quarters and dimes—a dollar for the reading and a dime for the pack of dogs she always kept. People still leave their change, sometimes for supernatural advice and some just to pay their respects, as I have always done. It is a small price to pay to cover your butt when dealing with the paranormal.

Even now, "Savannahsmith098" wrote, people visiting her grave "ask who they would marry, [and] the name is spoken clearly." Also, expectant mothers "reported that the sex of their baby was said."

According to Haley, when you scatter four quarters on her grave, "by the time you walk back to your car and turn around, the quarters will be stacked up."

When "Wendie1au" was in high school, she and several friends visited the grave one Halloween, where they found "three solid black kittens playing on top of her grave slab," although there were no cats anywhere else in the cemetery. Wendie1au refused to leave the car, but a friend picked up one kitty and asked her to pet it. "I told her to put it down. She did and it ran right back to Mayhayley's grave and sat down and looked back at us. I told them it was time to leave." She never returned.

Over the years, vandals, reportedly primarily students from the University of West Georgia in Carrollton, chipped pieces off Mayhayley's stone for souvenirs or talismans, or on a dare, although tragedies allegedly befell the perpetrators. Legend has one or more teenagers killed in car crashes after disturbing the grave. Investigating officers could never find reasons for these wrecks. Other offenders have reportedly been "cursed with horrible bad luck," reported Katie. Those vandals lucky enough to survive Mayhayley's curse soon returned the relics to her grave.

"HappyHalloween" was one of four boys who went to Mayhayley's grave, where one "got drunk and then proceeded to cuss her out into the air and eventually took a pee on her grave." Soon each of the young men were involved in separate car wrecks in which every vehicle flipped over. Further, drinking was not involved in any of the accidents. "Now what are the odds of that happening?" he wondered. "We must have really ticked her off."

On December 17, 2008, "pencilpusher" was with a girl who had always wanted to visit Mayhayley's grave but had never found anyone with the nerve for company. Since he was fortified with "liquid courage," pencilpusher drove them to the church, only to encounter a man who chased them away. They returned later, but at the grave "she runs back to the car, screaming cuz she swears she heard voices."

Pencilpusher later heard that "anyone who stands on her grave had a curse put on them and will die soon after…the last dude got his head cut off at work 3 weeks later."

"Savannahsmith098" related a story that Mayhayley predicted that her grave would be struck by lightning, some say three times, and fall. Her tombstone did break into two pieces. A portion of it was donated to the Heard County Historical Society, where it is displayed, and the church installed a new one. Engraved on both is a Bible verse, chosen by Mayhayley, John 7:5: "For neither did his Brethren Believe in him."

In life, Mayhayley kept thousands of dollars in cash secreted in her house and buried in the yard, leading to rumors that she still has undiscovered treasure, including in her casket. A concrete slab was laid down to prevent folks from digging up her coffin to locate the alleged booty with her body.

While in high school, Mike knew a great-granddaughter of Mayhayley's who told him that she and friends once held a séance to contact the fortuneteller, "and they heard the rattling from Mayhayley's beads and ornamental chains she always wore." The other girls were so frightened that "they would not discuss it."

One person reported that her grandmother had started writing a book about Mayhayley, until "she began having vivid dreams of Mayhayley and one day, a woman from the other side of the country called her to tell her Ms. Mayhayley was happy she was writing about her...but had no idea how this woman got her number, nor how she knew about her writings." Frightened, the grandmother "put all the papers away and decided not to pursue that book."

Tonya worked for Heard County 911, as did her mother. County deputies are part of her extended family, particularly Big John, an older, kindly man. Tonya wrote of Mayhayley on the Childbirth.org website,

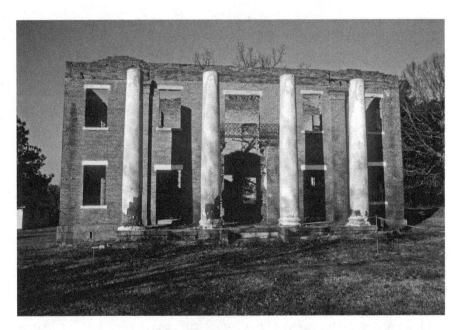

Mercer University originated in Penfield. One can imagine the ghosts of students past still walking its original grounds. *Jim Miles.*

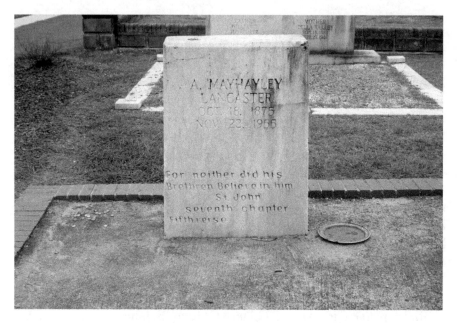

Dead half a century, Mayhayley continues to attract people who desire a reading. Leave $1.25 on her grave and you might hear from her. *Heard County Historical Society.*

"Big John swears she has 'told' him where things were, and has helped him solve cases on several different occasions. He even spends the night watching her headstone and protecting it from vandals on Halloween night. Big John takes the money people put on her headstone and collects it 'til he has a good chunk then takes all of it to the preacher for the upkeep of the cemetery." Many have encountered the man who keeps watch over the cemetery, as have I.

On December 22, 1995, Tonya's daughter, Kristyn, died of SIDS. After long thought, she and her husband decided to bury the child at Caney Head Church so "Big John would keep an eye on her too."

Tonya visited the cemetery weekly. On Valentine's Day, she took two carnations—one for Kristyn and the other for Mayhayley. On St. Patrick's Day, each received a green candle in a decorative tin, and at Easter, Kristyn received flowers and Mayhayley a wreath. At each visit, Tonya left all her change at Mayhayley's grave for Big John to collect.

Tonya could not afford a headstone for Kristyn. During one night shift, Big John appeared for his morning cup of coffee and gave Tonya a folded bill. "He said Ms. Mayhayley told me I should give this to you, so Kristyn

can have a marker," she wrote. It was $100 bill, which helped purchase a heart-shaped stone for Kristyn's grave. Tonya soon became pregnant again. In appreciation and respect, the child was named Aleysha Mayhayley.

"Poveglia99," on www.GhostForce.com, described the experiences of Carol concerning Mayhayley. The woman laid her eyeglasses on a wall of the cemetery before searching for Mayhayley's grave. When she left, the glasses could not be located. "Looking all over they finally located them on the opposite side of the cemetery. The glasses had apparently moved on their own, or according to Carol, Mayhayley moved them."

One night, Carol removed some plastic daisies from Lancaster's grave and took them home, where she put them into a clear plastic baggie and stored them in a dresser drawer. "A couple of weeks later Carol checked the baggie and the flowers were gone. Just the sealed plastic baggie was left in her drawer. Carol always said that Mayhayley had come and took back her flowers."

HOUSTON COUNTY

THE WHITE WISPY PRESENCE

Carol, her husband and their children inhabited a large Houston County home outside Perry. One night in the early 1980s, she spotted "something white and wispy" in the foyer of the house. After describing it to her husband, he dismissed the incident, explaining that she must have been tired. After a second encounter, he insisted that "it was probably the light from the TV." He would admit that the phenomenon was unexplainable, but only after his own encounter.

In 1994, ten years following the spook's debut, it was still sighted regularly and had established a pattern of behavior. After entering via the front door into the foyer, it made a left turn down the home's main hall and drifted in and out of the four bedrooms, always ending up in Carol's room, the master bedroom. On a number of occasions, she trailed the phantom, which disappeared when she confronted it.

"It doesn't have any features," Carol told Sheron Smith of the *Macon Telegraph* in 1994. "It's just this smoky, milky spirit, about six feet high. It likes me best. Even now, it stays in the kitchen with me a lot. It's tapped me on the shoulder, it's given me a light push, it's moved things around in the house. It's not really harmful. But sometimes I wish it would leave me alone."

Carol heard that the son of the previous owners died out of state, and the parents held a memorial in the backyard. Perhaps that explains the haunting.

JASPER COUNTY

THE HILLSBORO HORROR

In 2001, Andrew Calder, a central Georgia paranormal investigator based in Dublin, explored a case from Hillsboro. A couple with four children, ages six to fourteen, had purchased a home constructed in 1902 that had been the scene of several tragic deaths. In the backyard was a grave with a headstone so old that no engraving survived. It was thought to be a boy who drowned in a well located beside the house that was subsequently filled in. Early in the twentieth century, a woman was killed by a truck on the adjacent highway. She was thought to have been the mother of the drowned child.

The phenomenon in the house was particularly centered on a six-year-old daughter, who had nightmares almost every night—dreams of being pursued by parrots and pigs that wanted to eat her. At times, she fell into a trance that her parents were unable to break. On one occasion, her eyes rolled back in her head as she began an evil laugh that continued for at least ten minutes. After recovering from the frightening episode, she had no memory of the experience, which suggested demonic possession. She also had repeated encounters with a little girl clad in a dress. The figure resembled a cardboard cutout, and the child conversed with her.

Another daughter reported seeing an "old woman giving medicine to some monsters" in the house. Describing the creatures as "hairy and very black," she refused to reveal additional details when questioned by her parents

The mother heard unidentifiable noises emanating from the attic, and an old-time radio could be heard playing when no such appliance was on in the dwelling. She also felt an unseen presence sit beside her on the couch one

Wells were common gathering places in early communities, including this one at Shady Dale. The spirits of some residents linger. *Jim Miles.*

night. The most frightening episode occurred on another evening when a force grabbed her nightgown and with considerable force first pulled it down and then yanked the garment over her head. On a number of occasions, she saw shadows moving in a hallway. She often thought the house was haunted by multiple spirits that she did not fear and one she considered evil.

The father occasionally observed "a small red figure" in the living room that would abruptly disappear. Once, while lying in bed, a voice whispered

in his ear. The situation was so serious that the children were reluctant to leave the school bus in the afternoon and return to their home. The family spent a week in a motel for a respite from the disturbing phenomenon.

On February 11, 2001, three investigators arrived and conducted a survey between 9:00 p.m. and 2:00 a.m. In the front part of the house, a streaking globule was filmed, a thermal scanner detected a sudden twenty-degree drop in temperature and cold spots were encountered. Shadows were observed in the hallway, and a family dog "barked throughout the night at something invisible." Photographs captured a face materializing in a white cloud, a glowing area where the temperature drop was detected and a whitish cloud outside where the boy met his death in the well.

In the following months, Calder learned that the paranormal phenomena continued to be experienced by the family, particularly by the mother, and often when she was alone. She felt a presence while showering.

The fourteen-year-old son was showering one day while a boom box played his favorite tape. He heard a button click, and the sound ceased. Investigating, he found the player turned off. He switched the tape on again, and that routine was repeated three more times. Exasperated, he shouted for the nuisance to stop. In response, the tape was ejected onto the floor, and the boom box again turned itself off.

Nightmares continued for the six-year-old girl, and eventually all three daughters had experiences with the child, previously seen only by the youngest.

The family had spent a considerable sum purchasing and remodeling the house and did not want to leave, but considering the ghostly activity, they were forced to entertain the idea. After an attempt to direct the spirits to follow the light failed, the decision was made to involve the clergy in a supernatural intervention.

On April 15, Calder and a minister arrived at the home for counseling and prayer. The adults gathered in a circle to take turns praying. As Calder prayed, he sensed a presence behind him and felt "unusual physical sensations" on the back and head, as if being pressed down and encouraged to cease praying. As the minister began to pray, the sensation intensified for a time but was replaced by a feeling he could only describe as "divine," a feeling "that flooded my being, filling me with peace and pure energy." Later, the minister said that as he prayed, he felt the same vibes. When Calder contacted the family three months later, the home was described as peaceful.

JEFFERSON COUNTY

SOMETIMES DEAD MEN *DO* TELL TALES

In 1942, W.C. Smith was a forty-two-year-old man who operated a gas station in Wadley. On the night of January 9, he started for home at 9:00 p.m. with the day's receipts, $150, but never arrived. His wife called Chief of Police Charles Spell, but Smith could not be located. On the following day, two hunters returning home took a shortcut behind a church and found the body. Smith had been killed by a shotgun blast.

The ghost of slavery haunts Georgia's history. This slave market still stands in Louisville. *Author's personal collection.*

Several weeks passed and not a shred of evidence emerged. Police did not expect anything to develop, but one morning, Smith's eight-year-old daughter, Mary, stopped to see Chief Spell and related a strange story. "My father came to me in a dream," she said, according to *FATE* magazine in October 1955, "and told me he was killed by three men."

Mary named each man and gave enough details that Spell called the Georgia Bureau of Investigation's head, Captain S.W. Roper, who dispatched investigators T.M. Price and J.E. Eddy. Their investigation revealed enough evidence for the arrest of the three men named by the girl: Clifford Salters, thirty-four; Alvin McKenzie, nineteen; and Morris Mincey, also nineteen. Each made a statement admitting their guilt and signed the confession. Salters and McKenzie had hidden behind the church while Mincey lured Smith behind the church with the story of a concealed gallon of whiskey. From the grave, Smith's ghost had solved the mystery of his own murder.

JENKINS COUNTY

THE HAUNTED STATE PARK

Few people are aware of this fact, but there was another major prison for captured Federals in Georgia during the Civil War, Camp Lawton, located at Magnolia Springs near Millen. Housed there were 10,279 soldiers, and up to 1,000 died. There are documented Civil War ghost sightings here, along with a good bit of other paranormal activity as well.

Wade Huffman was assistant manager at Magnolia Springs. A native of Twiggs County, he had formerly worked at Laura Walker State Park in the Okefenokee Swamp near Waycross and lived in a house on the grounds of the former prison site. "Our group camp," Wade said, "which is on the other side of our lake, has six or seven buildings, and in one you will always find a light on when there is nobody in the building. No one has reserved the building and you turn the light off and by the time you get back across the lake the interior light is on again. We attribute that to [Confederate general John H. Winder], the commissary general. We think he still lurks around. In any of those group camp buildings back there, you feel a presence."

"There's all kinds of little things happening all the time," Huffman concluded. Although the campsites are generally quiet, the cabins are quite active. "Some visitors mention that the hair on the back of their neck will stand up, like someone is watching."

During the thirty years that Connie P. Fitch worked at Magnolia Springs, she often heard stories about the accommodations. "Some of our guests report that they experience things in our cottages," Fitch said. "Cottage #5 is the one where they say the clock will run forward. They will get up

Some one thousand Union prisoners died in the Confederate prison camp at Magnolia Springs. Employees have freely spoken about their personal ghostly encounters. *Jim Miles.*

and notice that it is not correct and reset it and it will continue to do it the entire length of their stay. It's not just an isolated incident. Also, in one of the bedrooms it appears at night that there is a crack at the bottom of the wall where it meets the floor. They think it was a crack and the light was coming through it in the middle of the night, and they thought, 'Oh, that's just a car passing by.' But they get up in the morning and they realize there's no crack there."

Huffman confirmed the Cabin 5 stories, saying that guests "will see a light through the wall and when they open the door there won't be a light on. One of our maintenance workers will be in there and he will hear a voice saying 'Help.' He thinks it is one of us but there's nobody out there."

According to Fitch, campfire hosts, who are usually older people who live at the park for several months and do volunteer work, have had paranormal experiences. One volunteer

had a fire going and they had put it out, and then several days later it rained for two or three days straight, I mean a hard rain and she looked out one night about 9:30 when they were about to turn in and discovered a light.

At first she thought it was a camper coming in late, but she noticed that it wasn't moving and she realized it was the camp fire blazing up even though it was still raining. The fire was blazing and she heard a sound back in the woods that sounded like a flintlock gun being cocked. She has a lot of Indian heritage in her bloodline, and so she was better able to pick up on things like that than others would. She has experienced a lot of things, heard different sounds back up in the woods at different times.

Park manager Bill Giles encountered another curious phenomenon. "An old maintenance road runs straight through the woods that was the road the prisoners came in on from the railroad at Lawton Station," Giles stated. "We make rounds at night and I pulled up there about 10:30 p.m. and off in the woods I could hear singing which sounded like Negro spirituals," although campers in the park heard nothing. He acknowledged that people do "get out on the sides of the road and drink beer, but they don't sing Negro spirituals." The singing "sounded like it was moving this way down that road. I sat there on the edge of the woods for a few minutes just listening to it and it just faded away after five minutes."

Magnolia Springs State Park contains the prison site remains, highlighted by earthworks. There are also camping facilities and cabins. 1053 Magnolia Springs Drive, Millen, GA 30442; (478) 982-1660; http://gastateparks.org/info/magspr.

JOHNSON COUNTY

SHINING A LIGHT ON THE SUPERNATURAL

K arl lived in an old house just outside the city limits of Wrightsboro on GA 15, as he posted on Ghosts of America. One evening, he and a friend stood around on the driveway outside, talking. When his friend left, Karl started for his bedroom, located at the rear of his house. The switch to his room's light was mounted on the hall just outside his room, a not uncommon feature in older houses, particularly when retrofitted with electricity. He flipped the switch.

"All of a sudden the lights flashed as if the bulbs had just blown," Karl wrote. "As I looked into the room, I saw what looked like someone wearing either a white dress or a nightgown and my jaw and neck went numb."

The experience caused Karl to race from his house and catch his departing friend, no doubt to discuss the frightening incident in his room. When he finally returned inside, he hesitantly flipped the light switch and peered into his room. Thankfully, "the lights came on with no problem and there was nothing in the room."

JONES COUNTY

A GENERAL'S GHOST

Jones County was created from Baldwin County in 1807, and one year later, a community developed around a cluster of springs. Initially named Albany, the county seat evolved in 1809 as Clinton, a unique historic treasure. A thriving early Georgia community, it was prosperous and once rivaled neighboring Macon in importance. However, Clinton was a victim of short-sidedness. When a railroad was constructed, the inhabitants decided that such a contrivance was too dirty, noisy and generally disruptive for a decent town to accept, and the tracks were routed through Gray instead. People and businesses moved to the railroad, leaving Clinton a well-preserved antebellum community.

One of Clinton's best-known residents was Alfred Iverson, a Confederate brigadier general of mixed competence. On the first fateful day at Gettysburg, Iverson, reportedly drunk, launched a poorly conceived assault that left the field littered with his dead. After the battle, his casualties were gathered up and buried in mass graves on the field. For decades, locals avoided the area at night, where the slain from "Iverson's pits" were believed to rise and roam the battleground.

Relived of his duties, Iverson returned to Georgia, where he somewhat redeemed his reputation. When Macon and Clinton were threatened by a Union cavalry raid in July 1864, Iverson routed the invaders at nearby Sunshine Church.

The Iverson House, now the Iverson-Edge House, was constructed between 1821 and 1826 by Alfred Iverson Sr. His son, the Civil War general, was born there in 1829.

Andy and Fran Greene-Collins, the latter once president of the Old Clinton Historical Society, purchased the dilapidated house and restored it while managing to live there. Before restoration, Fran and Andy took friends Donna and Robin Massey on a late day tour. In a front hallway, Donna gasped and hugged herself, wrote Wayne Dodson in *Middle Georgia* magazine. "She had goose bumps and it scared me because I thought her eyes were going to roll into the back of her head and she would start talking in tongues or something," remembered Fran.

The party immediately left the house. Donna had felt a strong female presence in the building. The group circled the structure and approached it from the other side, where Donna was overcome with the same feeling. Years later, Donna and Robin only visited their friends at that house during daylight hours.

The contractor installed a new door between the library and hallway, but it never quite worked right. When left partially closed, it opened itself fully with a hideous creaking sound, so the door was always left open. One night after the remodeling, Andy arrived home late and heard the door creaking. He called the sheriff and waited outside for the arrival of law enforcement officers, who scoured the house and discovered no evidence of intruders. Andy, who continued to feel strange in the library, believes that bodies were laid in state in the room. Some say that General Iverson's ghost still strolls through the house.

LAMAR COUNTY

STRANGE THINGS HAPPEN

Ruben Arnold Ware Sr. once inhabited a mill village near Barnesville. He described his early life in a book, *Memories of a Linthead*.

One Saturday night, Ware's mother hosted a candy pulling party at their house for the young people of the community. At about midnight, the party broke up, and the adult chaperones retired to the front porch for a cooling breeze and gossip. They particularly enjoyed observing the full moon. Suddenly, Mrs. Maybelle Burke, described as being very religious, exclaimed, "All of you look at the moon, how large it is getting, and it is coming right at us."

Ware also witnessed the phenomenon, writing, "it kept getting bigger and coming faster, and when it reached the front of our house, it seemed to be trying to tell us something." Frightened, Ware held on to his mother as all the witnesses cried and prayed. Mrs. Burke broke into an unknown tongue and then started testifying to the assembled, "telling everybody that the figure we saw in the moon was the Lord, and he gave her a message to deliver to all the mill people," Ware wrote. The message was, "We would hear of a death of a person close to us before the sun rose."

The sheriff soon pulled up and explained that a Mr. Whit and Sarah Chapman had been driving along Cemetery Road. While negotiating a curve at the graveyard, Whit lost control of his Model A and crashed violently into a light pole. Chapman was dead, and Whit was seriously injured.

Whit, a local athlete, was a notorious ladies' man although he was married. Evidence indicated that the couple had been drinking whiskey

A "phantom hitchhiker" story originated in Barnesville after a young girl was killed when her car struck a pole in front of this cemetery. *Earline Miles.*

and fooling around at the time of the accident. To make matters worse, Sarah, a beautiful girl with long blond hair, was only fifteen. Sarah's father, a widower, was raising his daughter alone, and her death devastated him. At the funeral, he kept saying, "Sarah will come back. She just can't be gone forever." Sarah's ghost did appear to her father, promising to return home.

One year to the day after Sarah was killed, a motorist spotted a young woman walking along Cemetery Road after 1:00 a.m. He stopped and offered assistance. The lady asked to be taken to her father's house and gave his address. For propriety's sake, the man let her into the back seat and drove her home, but when he opened the back door for her to exit, she had disappeared.

Disturbed, the man knocked on Mr. Chapman's door, rousing him from sleep. Sarah's father asked for a description of the hitchhiker. The driver described a pretty girl with long blond hair. Chapman began weeping and told of his daughter's demise. The troubled motorist continued into Barnesville and described the incident to the sheriff, who confirmed Chapman's account.

Each year, a motorist was enlisted to take Sarah home, "and it got so that on the anniversary of her death, Mr. Chapman would not retire until someone came by telling the same story about picking her up," Ware wrote.

In the 1920s, when he was seventeen, Ware and his best pal, "Sweet Pea" Jackson, had attended a party in Barnesville one night. Afterward, they hoped to hitch a ride home with a friend. That plan did not pan out, so they walked toward home, two miles distant, along Zebulon Road, locally called Cemetery Road because it bordered the city's principal graveyard. They were talking when Sweet Pea exclaimed, "Hey, look, there's a girl walking in front of us!"

The girl was only twenty feet distant, and they saw that she had beautiful legs and long blond hair, Ware told the *Macon Telegraph* in 1994, when he was eighty-one. "Sweet Pea," Ware said, "let's catch up with her and see where

Lonely, rural roads harbor spooks that haunt the dirt lanes in search of a never-found peace. Sometimes they seek severed appendages. *Earline Miles.*

she's going." Although the girl "never speeded up," Ware continued, "we could not gain on her...she just seemed to glide effortless."

Sweet Pea hoped to identify the girl when she passed beneath the cemetery light, where Sarah had died. "But when she got to the light she disappeared," and "after we got out of the light, there was this girl again, and at the same distance. I said, 'Come on, Sweet Pea, we will run and catch her.'" The boys broke into a run, but still they could not close the distance. At the mill town, the girl turned toward some houses, and the boys continued home.

On the following day, Ware described the previous night's adventures to his sister. She listened carefully before saying, "I don't want to scare you. But you boys walked home with Sarah Chapman."

"You mean the ghost?" Ware asked with an eerie feeling, and she replied, "I sure do." Ware and Sweet Pea never walked that route home at night again.

For decades, Barnesville was known for the hitchhiking ghost girl. "Barnesville is full of ghosts," Ware declared. And he experienced one.

In 1965, Dickie Lee released a song he had written, "Laurie," with the spooky subtitle, "Strange Things Happen." It is a classic teenage death song from an era filled with them and is resurrected every Halloween. The

song did not introduce the legend of the ghost hitchhiker; it was merely a reflection of a universal story localized across the country, but this tale from Barnesville was one of the earliest.

A few copies of *Memories of a Linthead* can be found online for premium prices, and it can be requested through interlibrary loan. Be warned that it is risqué.

LAURENS COUNTY

A BLACK-CAPED MAN AND THE POSSESSED FELINE

Stephanie Miller is a senior reporter and business page editor for the *Dublin Courier Herald*. In a Halloween column for 2004, she described the ghost that lived with her sister, Karen; brother-in-law, Chris; and their children, sons Erik and Jordan and daughter Kristen.

When Karen and Chris purchased their home twenty years before, it consisted of two buildings—one from the late nineteenth century and the other from the 1930s. The older portion, in poor condition, was demolished. The remaining section, four rooms, was remodeled and additions built. Such activity is notorious for eliciting responses from ghosts. Also notable is a well that was once incorporated into the house but was left uncapped beneath the newly reformed house. Paranormal experts find that spirits are either drawn to bodies of water or appear to draw energy from them. Perhaps the resident spirit was unhappy from the start, for the renovations generated "one accident after another," Miller wrote.

As they moved in, Karen thought that something was not right in the house. Later, "she started catching glimpses of a hooded, cape-draped figure walking in the hallway, which goes through the bedroom section of the house" in the oldest part of the structure, Karen told Stephanie. "She said she could be sitting in her living room and feel a spirit presence come into the room with her."

Stephanie described her experiences to Chris, but he did not believe her. Before long, their youngest boy, Jordan, began having nightmares about a person wearing a black cape who stood at the entrance to his room. "I'd tell

him it was just a bad dream," Karen said, and she would describe the dream to Chris, adding that she had also witnessed the figure. Chris said it was merely a nightmare. "But I know it wasn't," she stated.

Although the presence was disturbing, Karen did not believe "it was a bad spirit because it never did anything except walk in the hallway and look in our doorways until one night I woke up and saw it standing next to my side of the bed," she informed Stephanie. Karen attempted to scream but was unable to and felt as if she were being smothered. Her convulsions woke her husband, but the entity vanished before he could see it.

Ten years after they occupied the home, the family took a trip to Disney World. Stopping at an antique store on the way home, they encountered a woman with a registered Himalayan cat that she was unable to keep anymore. Chris was persuaded to accept a cat in the house, and once home, Karen purchased everything necessary to spoil the new pet.

The first few weeks went well and Karen and all the children loved the animal, but then the cat started to behave strangely. The boys, then thirteen and eleven, came to dislike it, saying they feared the animal. Eric and Jordan refused to allow it to enter their rooms and became upset if it even approached them.

One day, while Karen was out running errands, she received a frantic phone call from the boys, "screaming she had to come home." Karen found the boys huddled in Eric's room, the door locked and her sons armed with BB guns, "screaming for her to watch out for the cat....They said, 'Mama, a demon's got in that cat and it's talking.' They were so scared they would not come out of the bedroom until I took the cat out of the house," Karen said. She was forced to give the cat away that day because her sons refused to share their home one additional minute with the creature.

Eight years after the incident, Miller gathered the family together and asked what had happened with the cat. Karen had loved the animal but admitted that it had started acting weird. One day, as she and Jordan were in the living room, the cat jumped on an ottoman, stared straight at them and meowed in a way that sounded like a human saying, "I'm watching you."

On another occasion, Eric and Jordan were playing a video game when the cat pounced on them, inflicting numerous scratches before they drove it out of the room and closed the door. They also "said the cat sounded like it was talking again," Miller wrote. The boys were so terrified that they decided it was them or the cat—something had to leave the house.

Apparently, this was not just a case of a deranged cat, for the family obtained a poodle named Chelsea that was also influenced by the presence

in the home. Based on Karen's description, Miller related that "the little poodle would get all bristly like something was in the house. She said the dog hated that hallway. Chelsea either stayed in Jordan's room, Kristen's room or in the living room."

The ghost persisted until about 2002, when Karen heard a minister preach about casting demons out of a residence. She went home, anointed every door and window with oil and prayed that the ghost would leave, "and she hasn't seen so much as a shadow since," Miller concluded. For this family, it was good riddance to a bad spirit.

MACON COUNTY

GEORGIA'S SLEEPY HOLLOW GHOST

G eorge Slappey was an eminently successful peach farmer, pharmacist and entrepreneur who opened the Austin Theater in Fort Valley. As a party palace, he constructed a two-story hunting lodge he dubbed Sleepy Hollow Farm on nine hundred acres just inside the Macon County line. Parties often started there on Thursday and lasted throughout the weekend, with "drinking parties, dancing, and debauchery" the norm, wrote Billy Powell in *Echoes from the Valley*. There was a ballroom and two pianos—one for square dancing and the other for round dancing.

Slappey was a womanizer, and that brought about his demise. He lusted after the wife of E. Lynn Fagen, his overseer, and on July 20, 1934, Fagen shot his employer to death. The trial, held at the Macon County Courthouse in Oglethorpe, attracted a crowd of five hundred. Fagen readily admitted that he had shot Slappey but explained that the wealthy man was lunging for a pistol when Fagan struck him over the head with his own gun, which accidentally discharged. The male jury, deciding that Fagen had been properly defending his honor, acquitted him.

As a young teen, Billy Powell heard many stories of hauntings at Sleepy Hollow. There were tales of doors and windows slamming on their own, of sobbing from upstairs and horrific screams and "an unseen presence felt on the staircase." A pond at the site was said to be the scene of three mysterious deaths. Two farm workers had unaccountably drowned in the black water, and a woman, crossing the pond on a footbridge, had fallen backward and died of a broken neck. It was said that a phantom hand

would emerge from the pond and drag additional victims down to the murky bottom.

Throughout the 1940s, 1950s and 1960s, teenagers frequently visited Sleepy Hollow in the night—boys to challenge one another's courage and couples to park in an exciting, forbidden place.

One night, in March 1953, Billy Powell, in the company of two other boys and three girls, reached Sleepy Hollow at 11:00 p.m. They followed the slim illumination provided by a single flashlight into the building. Billy remained at the foot of the staircase as his friends ventured upstairs to the site of the murder. While listening to his friends laugh and squeal upstairs, "I distinctly felt a presence and a rush of cold air as if an unseen spirit had passed me going down the stairs," Powell wrote. "My hair literally stood on end. I wanted to get out of there, and quickly. I hollered to the group: 'Let's get out of here; there's a ghost in this place!' A stampede ensued."

Sleepy Hollow was demolished in 1968, leaving only a chimney and basement foundation on Doles-Sleepy Hollow Road off GA 49. *Echoes from the Valley* is available in bookstores and online markets.

MARION COUNTY

THE SPIRITS OF ST. EOM OF PASAQUAN

Eddie Owens despised his life in rural Marion County, where he, his parents and six siblings survived as sharecroppers. During a full moon night at the age of twelve or thirteen, Owens entered a thicket and prayed earnestly to be a unique person. "And by God, I think I succeeded in that prayer," he said later. God, or whatever sprit he contacted, told him he was St. EOM of Pasaquan, the word *Pasaquan* meaning "where the past and the future and everything else comes together." He would have the ability of bringing the past to the future, which was a good thing.

"You're gonna be the start of something new, and you'll call yourself Saint EOM, and you'll be *Pasaquan*—the first in the world," Martin told journalist Tom Patterson for his book, *St. EOM in the Land of Pasaquan*. He embraced "man's lost rituals," which were God's rituals forgotten by humankind. Strangely enough, these rites involved long hair and beards. St. EOM began cultivating his own hair, believing that society was doomed unless it relearned "the art of the hair, and braiding of it and controlling it to grow upward instead of downward."

At age fourteen, St. EOM departed Marion County for New York City, living as a healer and fortuneteller and using tea leaves and cards for divination. He was also a hustler, pusher, gambler and bartender. Returning home in 1935, St. EOM fell desperately ill for two weeks; his family feared he would die. "And during the worst night of all, when I thought I had died, my spirit seemed to leave my body," and he had a vision of a "great big character...sittin' there like some god, with arms big

The creator of Pasaquan, St. EOM, predicted the death of a man who perished in an accident on his way home. *Jim Miles.*

around as watermelons." He would live, he learned, but only if he followed his spirit.

St. EOM educated himself, studying the ancient art of Asia and Mesoamerica, Atlantis, Mu, Africa and Easter Island. St. EOM's outlandish art environment started in 1950, when his mother died and he returned home to farm and design. With cement, he manufactured an image of Shiva, a Hindu god. Before returning to New York, he told his tenant farmers not to pass the statue because they would die.

Another vision was received in 1957, ordering him, "Get up from here and go home." Back in southwestern Georgia, he provided readings and labored for three decades with cement and gaudy Sherwin-Williams paints to create an exotic, four-acre fantasy art compound. The design was "in my mind," with weird symbols that "represented the universe and its forces and the great powers that held all of this here planet together"—the knowledge revealed by the spirits. On the property, he created temples, pagodas, shrines, altars and totems, all adorned with the symbols, faces, naked human forms, long serpents and a menagerie of fantastic creatures. He assembled a large wardrobe of costumes, brightly colored ceremonial robes, capes and feathered headdresses.

St. EOM would greet visitors with his "shaman yell," which allowed him to judge their vibrations. His German shepherd guardians would not bite, he said, "if you don't have no evil thoughts." A former employee of St. EOM said the artist would communicate with two of his crafted faces, "in some kinda language I couldn't understand and makin' all these wild sounds."

On April 16, 1986, St. EOM wrote a note, "No one's to blame, but me and my past," and shot himself in the head. Clad in one of his signature robes, he was interred at Ramah Primitive Baptist Church. The message on his marble slab, "St. EOM Pasaquan July 4, 1908," suggests that he is still around, at least in spirit.

The following story was related by Fred C. Fussell, an artist, photographer and exhibits curator in Columbus who has done extensive work at Pasaquan. During the early 1970s, with the United States still embroiled in Vietnam, carloads of newly minted soldiers, finished with basic training at Fort Benning and awaiting transportation to the war zone, followed the highway to Pasaquan. All these anxious young men wanted a session with St. EOM, the seer famed throughout the Deep South, to tell them their prospects for survival in Southeast Asia. Some believed that they would receive their true fate; others considered it a diverting excursion.

Thousands of people had sought St. EOM's advice concerning love, health and lottery numbers, as well as to hear of other events in their futures. One carload of four young soldiers was having a good time on the trip, music blaring from the car's radio as the men made boisterous claims about their virility and military skills. One of the four was a staunch skeptic of St. EOM's ability, dismissing the "bullshit" that psychics dispensed to the gullible in order to separate their marks from their money. He had no intention of seeking wisdom from a self-appointed saint ensconced in his gaudy compound.

One by one, the other soldiers entered St. EOM's exotically decorated parlor and quietly asked the seer, clad in one of his many outlandish costumes, their fate. Their skeptical friend remained in the car, music blaring loudly from its speakers.

As St. EMO concluded the final reading, he asked the young man to wait a few minutes. The reader left the room, returning with a sealed white envelope. "Give this to the young boy who refused to come in," he directed, "and tell him not to open it until he gets back to Fort Benning."

On the ride back to base, the three who had sought a reading described their experience and the knowledge confided to each. The fourth man smirked and insulted his buddies, thoroughly enjoying his skeptic's role.

The folk art compound at Pasaquan is based on the spiritual philosophy devised by its creator, St. EOM. *Jim Miles.*

When the driver sped up to pass a slow car, he lost control and the vehicle left the pavement, overturning multiple times before coming to rest in a muddy, red clay gully.

Other motorists stopped to aid the men. Three of the boys survived their injuries, but the skeptical soldier had been killed in the accident, St. EOM's sealed envelope clutched in one bloody hand. His shocked companions nervously tore open the envelope. Inside was a handwritten note in St. EOM's distinctive scrawl: "This man has no future."

Some visitors report having been disturbed by "weird vibes" at Pasaquan and had to vacate the property.

Pasaquan has undergone a full restoration by the Kohler Foundation and is now the property of Columbus State University. Check for limited visiting times (http://www.pasaquan.blogspot.com).

McDUFFIE COUNTY

REPORTER ENCOUNTERS SPECTER

The two-hundred-year-old Bowdre-Rees-Knox House, located on Old Wrightsboro Road near Thomson, was constructed in 1806, and over the years, it had gotten a reputation for being haunted. On October 22, 1999, Mark Mathis and Jeff Janowsky, reporter and photographer for the *Augusta Chronicle*, respectively, were informed that they would spend a night at the house for a Halloween feature.

Foolishly, in preparation for the adventure, Mathis bought a copy of *The Blair Witch Project*, and on the night before the assignment, both men went to a movie theater in Thomson and watched *The Sixth Sense*. That definitely put them into a ghostly state of mind.

The news team visited a real estate office where Andy Knox, whose family had owned the house for three generations, provided background. No one had lived in the house for a decade, but it had been recently renovated and was used for dinners by the Belle Meade Hunt Club following fox hunts. Knox had experienced nothing unusual, but Epps Wilson, who had lived there in the late 1970s, described "the time he heard footsteps coming up the stairs to the attic where he slept. Another time he heard tapping on the window by his bedroom, which was on the third floor of the house," Mathis wrote. The sound was not created by wind or tree branches, Wilson explained. "Knuckles tapping on glass make a very distinct sound."

Wilson also described the experience of a housekeeper who once encountered a woman dressed in clothing from the late nineteenth century in the basement. The ghost stared at the woman and wagged a finger at her

as if she was not welcome there. Wilson believed that there were ghosts in the house.

Mathis and Janowsky talked to Freddie Robinson, who had spent most of his life working on the building. He had observed lights moving within the house at night, and occasionally a single light shifted around the exterior. While unsure of a haunting, Robinson did allow that "something is wrong with that house."

Kristin Preston, a local resident then nine years old, swore that she had seen the three ghosts that occupied the house. The attic was inhabited by a Casper-type ghost that was friendly, she explained. It had green eyes and periodically drifted downstairs to keep an eye on things. A woman in a white dress haunted the basement, while a man, apparently once her fiancé, dwelled on the second floor. The woman got mean around the male because he left her at the altar in the 1900s. The couple argued at midnight, and according to Kristin, the lady planned to kill the man.

Most locals talked about the haunted house, but few approached it, even in daylight. A Belle-Mead employee who escorted Mathis and Janowsky to the house declared that the men were either stupid or brave. When asked if he had experienced anything odd in the house, the man replied, "I believe in it enough to not go up there and mess with whatever's there." When the employee left, he said ominously, "We'll come by tomorrow to see if you're still here."

The team had been shown mattresses located in the attic, where they found scratched on the walls, "Do it and Die" and "I'm dead." The dust convinced them to crash on couches downstairs, where they laid out their sleeping bags. Very deliberately, they explored the house, opening each door.

Mathis and Janowsky played cards until 1:00 a.m. and went to bed, although little sleep was had. Both felt that they were being watched throughout the night. Mathis heard basement doors slamming and had an experience that left his puzzled. "I'm halfway between being awake and asleep when I hear creaking on the stairs that descend from the attic and the sound of a girl's voice. Paralyzed, I stare straight up at the ceiling. My pounding heart and the approaching footsteps are the only things breaking the deafening silence. Something is coming across the floor of the den toward me, but I'm still frozen in fear. Slowly, I see what appears to be a face coming over the top fold of my sleeping bag, which I am now using as a facial shield. Before eye contact can occur, I close my eyes and quickly begin saying the Lord's Prayer over and over in my head until I fall asleep."

He thought the incident "probably had been a dream," but "then again, maybe I'm just too afraid to admit it might have been real....I wasn't sure then, and I'm still not sure now if it was a dream."

The Bowdre-Rees-Knox House is located on Old Wrightsboro Road.

MERIWETHER COUNTY

FALA, THE FIRST DOG

"We don't have any ghost stories here at the Little White House," said Steve Lane, a tour guide at Roosevelt's Little White House State Historic Park, "but we do have the story of Fala."

Fala, a black Scottish terrier, was born on April 7, 1940. After FDR's cousin Margaret "Daisy" Suckley presented the dog, then known as Big Boy, to the president, he renamed the dog Murray the Outlaw of Falahill, for a Scottish ancestor. Fala became FDR's best friend and was known as the most famous dog in the world.

Roosevelt's breakfast platter arrived each morning with a bone for Fala, and the animal received a full dinner every evening. He slept in a special chair at the foot of Roosevelt's bed. Fala traveled with the president by car, train and ship, sitting beside Roosevelt as he drove his Ford with its special hand controls that accommodated his disability. Fala was introduced to dignitaries from around the world and gladly performed his tricks for them, sitting up, rolling over and jumping; he could even twist his mouth into a smile. Fala traveled to Mexico and Canada and attended the 1942 Atlantic Charter Conference in the company of Winston Churchill. There was a comic strip starring Fala, and he was frequently mentioned in the *New York Times* and *Reader's Digest.*

Inevitably, Fala was caught up in the political sphere. When Roosevelt visited the Aleutian Islands in 1944, rumors started that Fala had been left behind accidentally and that, at the cost of millions of dollars, Roosevelt had sent a destroyer to retrieve the dog.

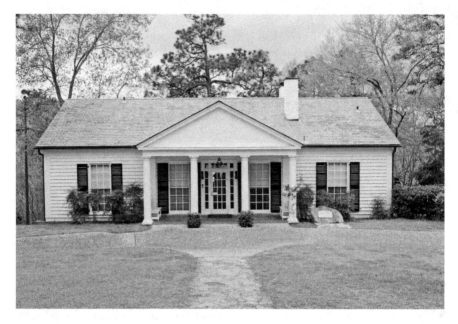

When President Franklin D. Roosevelt died at Warm Springs, his faithful dog, Fala, chased after his departing spirit. *Earline Miles.*

In the famous "Fala Speech," given on September 23, 1944, Roosevelt said he and his family expected harsh and unjust criticism, but he felt that similar treatment of his dog was unfair. His family was irritated, "but Fala truly resented" it, Roosevelt said. "His Scottish blood was furious," Roosevelt continued. He added that the pet had not been the same since. "I think I have a right to resent, to object, to libelous statements about my dog." This was actually a campaign speech delivered at a Teamsters Union dinner. The forty-minute address, totaling 3,200 words, only contained one paragraph about Fala, but that address will always be remembered as the "Fala Speech."

As the president fished on a trip to Florida, the catch piled up on the deck, with the creatures flopping about. Unbidden, Fala began imitating the fish, flip flopping through the air, an act he continued for some days. While aboard the cruiser *Tuscaloosa*, Fala found a line of sailors relaxing on deck without shoes. Fala made a game of running along the line, licking each man's feet.

Fala received thousands of letters addressed to him. In 1942, a film about the dog was made, and Margaret Suckley wrote a book titled *The True Story of Fala*. The film is shown today at Hyde Park, Roosevelt's home, and the

book is also available. A transcript of the "Fala Speech" and an actual film recording of Roosevelt delivering it are available on the Internet.

"On April 12, 1945, President Franklin Delano Roosevelt collapsed in the living room with a cerebral hemorrhage and he was taken from there into his bedroom and placed in the bed," said Steve Lane. The doctor was notified and he rushed right over from the pools and began to work on the president to see how serious his condition was. He contacted Washington, and another doctor was sent down from Atlanta.

But at the instant that Roosevelt fell forward, his little dog Fala was not too concerned, though everybody else was. There was a lot of commotion going on in the house, and Fala just simply backed out of the way. We have been told that he went into the kitchen and took a nap under the stove.

But two hours and twenty minutes after the president collapsed, Fala jumped up, almost as if shocked awake, and came rushing through the house barking and growling and causing all kinds of commotion. He hit the front door trying to get out. Something was definitely happening, the way the dog was reacting, and it was too late for anyone to get to the door and let him out. Fala turned to the window beside the door, which was open at the bottom to allow air circulation, crashed through the screen and headed up the walkway and was captured by either a Marine or a Secret Service agent up where the bump gate is located.

Fala knew that his master was gone and accompanied him as his spirit left. Margaret Suckley, who had given Fala to Franklin back in 1940, took possession of the dog when they left Warm Springs:

In Washington the president's body was placed in the East Room, where family members were able to go in and see him, and the following day, April 15, which was the anniversary of the death of Abraham Lincoln, his body was taken to Hyde Park, New York, where he was buried in the Rose Garden. What is interesting is that Margaret Suckley, who now kept Fala but would give him to Eleanor, had Fala on a leash as the president was being buried. She always said she thought Roosevelt was attending his own funeral, because Fala suddenly stood up, took a step forward, and did the president's favorite trick. He did a rollover and then he stood back up and sat down beside Margaret Sibley for the rest of the funeral.

Fala's death on April 5, 1952, was met with obituaries in a number of publications. He was buried beside the sundial in the Rose Garden at Hyde

Park, not far from his beloved master. Part of the FDR memorial in Potomac Park, at Independence Avenue and Ohio in Washington, D.C., is a figure of Fala. Patting its head is thought to bring good luck.

Roosevelt's Little White House State Historic Site is at 401 Little White House Road, Warm Springs, GA 31830; 706-655-5870; and http://www.gastateparks.org/LittleWhiteHouse.

MONROE COUNTY

THE OLD HAUNTED HOTEL

The Royal Palm Café and Inn in Forsyth, a two-story building, was erected in 1925 along U.S. 41, which was then a primary route through Georgia from Atlanta to Macon, an ideal site for Forsyth's first hotel. In 2006, Sue Fowler and her husband rented the property and developed the café and inn, which they managed. They were both witnesses to strange phenomena.

"Doors opening, then closing, then opening again," Fowler told the *Monroe County Reporter* for the September 14, 2008 issue, "lights going on and off, blinds going up and down, we've seen a lot. At first we were skeptical, or figured other people were in the building, but too many times when I was alone or just with my husband, we felt like we weren't alone. Guests have experienced it too."

Betty Mock, who resided in the building before the Fowlers' arrival, supported their observations. "Pictures would fall down, or objects would move," Mock said. "At first I thought I was going crazy and I would keep asking myself, 'Did I put that there, did I leave the door open, is anyone else in here besides me?' but after awhile I was convinced there were ghosts."

One night, two out-of-town businesswomen had rented two rooms of the Royal Palm. At 9:00 p.m., as Fowler exited the building for home, a fire alarm beeped a number of times. Nothing out of the ordinary, but in the morning, one of the women asked if the building were haunted. Fowler laughed, and then the other lady explained that she had not slept the previous night because lights and radios kept turning themselves on and off.

Residents of this Forsyth building saw lights flick on and off, doors open and slam shut and pictures fall from walls. *Earline Miles.*

One night, during renovations, while the Fowlers stayed in one of the rooms, they were watching television when the door to the room, which they had left half open, began closing and opening on its own. On another occasion, the Fowlers were painting the upstairs and left all the doors open for ventilation. During the night, the resident spook took the initiative to securely close each door. "There was a big picture hanging in one room that didn't just drop. It fell in the middle of the room and broke into pieces. There have just been some strange things that have happened."

The Royal Palm Café and Inn in Forsyth, located at 22 West Main Street (U.S. 41), has closed.

MUSCOGEE COUNTY

ST. ELMO'S SPIRITS

Colonel Seaborn Jones was an accomplished man before he migrated to Columbus. The native of Richmond County had been on Governor George Troup's staff, served as a state legislator and solicitor general, escorted General Lafayette on his celebrated tour across Georgia (1824–25) and been a successful lawyer and planter. In Columbus, he purchased 350 acres and vowed to build what one architect called a "bona fide Greek temple for a home," which he designed himself.

The mansion, started in 1828 and completed five years later, was surrounded on three sides by twelve Doric columns, each measuring three feet in diameter and forty feet in height, with a hanging iron balcony in front. The bricks of the eighteen-inch-thick walls, covered with white stucco, were manufactured on the property by slaves; the excavation where the clay was dug survives today as a pond. Seaborn Jones named his majestic home El Dorado.

The doors and stairways are mahogany, the floors are wide pine boards and the other interior woods are oak and cedar harvested from the estate. The great house has three floors. The ground level contained storerooms, a wine cellar, a kitchen and dining room and quarters for slaves. The top floors each have four rooms, separated by central hallways that extend the length of the building. Rooms on the second floor measure twenty by twenty feet, with fourteen-foot ceilings; the third-floor rooms are twenty by sixteen feet, with twelve-foot ceilings. A beautiful winding staircase leads to the top floor. Wooden pipes carried water to the house and on to Columbus.

An entire family chased St. Elmo's noisy haint, which created the sounds of dragging chains, wall knocking and scratching. *Author's personal collection.*

Remaining dependencies include the original smokehouse and springhouse, the latter where food was kept chilled during summers. Each side of the house had formal gardens filled with expensive statuary, and a garden graced the front. In the yard was a now vanished conservatory measuring fifty by twenty-five feet and filled with rare and tropical plants, including banana, orange and lemon trees. A three-hundred-foot-long scuppernong arbor led to a lake covered with waterlilies.

Visitors included Presidents James K. Polk and Millard Fillmore; Henry Clay, known as the Great Compromiser; General Winfield Scott; famed actor Edwin Booth; and noted English author William Makepeace Thackeray. In 1839, a future Confederate general, Henry L. Benning, nicknamed "Old Rock" for his steadiness in battle, married Seaborn's only daughter, Mary, and lived there.

The mansion achieved worldwide reputation through the publication of the novel *St. Elmo*, written by Augusta Jane Evans Wilson, a niece of the builder's wife. El Dorado was a model for the house in her book. "Many of the happiest years of my life were spent in this lovely house," Wilson wrote her aunt, Mrs. Seaborn Jones. Wilson spent long hours relaxing on a sofa in the library reading books and completed her novel in the house. She dedicated her second novel to her aunt.

In 1875, the house was purchased by Colonel James J. Slade, mayor of Columbus from 1891 to 1895, who officially changed the home's name to St. Elmo after the novel. The building hosted St. Elmo School for Girls in 1880. Slade's daughter, Florence, opened St. Elmo to the public in 1933. It was added to the National Register of Historic Places in 1971.

According to a *Columbus Enquirer* article written by Doug Wallace in 1947, a man who grew up in St. Elmo, Valter Wall, was firmly convinced that the great mansion was haunted. The house was beset by mysterious sounds that were relentlessly pursued by his father, Papa Robert Wall. The sounds took the form of the traditional dragging chains, knocks from the walls, scratching and other strange noises.

One night, Wall said, "we all heard a noise that sounded like somebody had dumped a bucket of dried peas on the back porch. But when we looked out there we couldn't see a sign of a pea anywhere." That was "only one of the noises we heard at night," he continued. "You know, everybody would hear the same noise. It wasn't just me. But we never could find where it came from."

Papa Wall would light a lantern and tour the vast structure, with Valter and other family members crowded behind. "One night Papa went clear

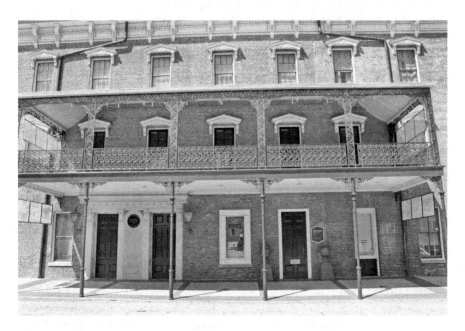

The Springer Opera House in Columbus is haunted by the great Shakespearean actor Edwin Booth, brother of assassin John Wilkes Booth. *Earline Miles.*

up through the top floor where furniture and things were stored and climbed out on the roof trying to trace a noise. That was the night we thought we heard the plaster fall in one of the rooms. We never did find whatever it was."

However, he continued, "The worst sound of all at night was the knocking. It would start sort of like this—knock, knock, knock—like you were knocking on a door not aiming to make much noise. Then it would get louder and louder until we all got up to see what it was. Then it would quit. We never did find out what caused that knock. It would start up just after we went to bed. Sometimes it would let up a spell and then, directly, start all over again."

Also living at St. Elmo at that time was twelve-year-old Essie, who thought the sounds were explained by their stable of cats, numbering eight. "One night most of the cats suddenly went mad for some reason," Essie said, "and Uncle Rob got all of us children into one room and herded the cats into another and got rid of them. Some of those cats were so crazy they jumped off the high railing...and landed two stories below." What phenomenon could have driven the cats into such a frenzy of activity and caused their suicidal behavior?

Philip and Margot Schley purchased St. Elmo's in 1964. Mrs. Schley said that their quiet ghost was fond of taking books, vases and other items and keeping them hidden for months. All the objects eventually returned to obvious places, where their presence could not have been missed before, she told Richard Hyatt of the *Columbus Enquirer* in 1982.

The ghost made itself known to Mrs. Schley before she had heard the stories, in 1965, "right after we moved here," she said. "I heard footsteps, a woman's footsteps, upstairs. It wasn't scary, not plodding, just someone going down the hall in high heels. I went upstairs, but no one was there."

The ghost of St. Elmo is a friendly but mischievous spirit that has never been seen. "She's a quiet ghost, not a sad ghost, not something to be scared of," Schley stated. "I've never heard her again since that one time, but strange things are always happening in this house. Things will disappear completely. You can go through drawers and chests and not find them, then they will reappear overnight. We joke about it; the ghost did this; the ghost did that."

The current tale, which apparently has no basis in fact (well, it *is* a ghost story), states that in 1847 John Abraham Jones, a son of Seaborn Jones, was to marry at El Dorado. An unidentified female relation, who had long been in love with her cousin, decided to disrupt the festivities by ingesting rat

poison and going to bed upstairs. When her act was discovered, the wedding was indeed postponed. The woman lingered for three days before dying. The couple then married.

El Dorado/St. Elmo is located at 2808 St. Elmo Drive, Columbus. Copies of the novel *St. Elmo* are readily available online.

NEWTON COUNTY

THE BISCUIT-EATING GHOST

In the weird of night when the lights are no more
And the clock on the mantel beats slower than slow,
A man walks forth with a measured tread.
He is not of this earth-the man's from the dead.
He walks with assurance, his tread is not light;
This man from the dead, seems to think he has right.
— *"The Ghost of Orna Villa," by Mrs. Paul Campbell, circa 1946*

In a community of grand houses, Orna Villa stands out. A large white frame house with four square pillars forming a portico, the structure has two single-story wings, three limestone chimneys, heavy hand-hewn timbers, broad hand-planed floorboards and carved mantels. Built in 1825, it is the oldest structure in Oxford.

Orna Villa was owned by Dr. Alexander Means, who helped found the community and college named Oxford. He was president and a professor of physics and chemistry there, as well as a physician and scientist. He taught at the Atlanta Medical College and became the first Georgia state chemist. A widely respected minister and orator, Means preached the funeral service for President Zachary Taylor and entertained President Millard Fillmore.

Means made a journey to Great Britain, where he had an audience with the queen and lodged with the famous scientist Sir Michael Faraday, who worked in the fields of electromagnetism and electrochemistry. Means began experiments in electricity, and on June 2, 1857, he summoned many

of Georgia's finest minds to Atlanta City Hall. He had invented a machine that produced frictional electricity, and when it passed through wires to an element of black carbon, the room was lit by incandescent light. At that time, Thomas Edison was but ten years old. Means is alleged to have developed the electric light long before Edison, but unfortunately, he failed to patent his invention.

In Oxford, Means conducted his experiments in a laboratory established on the second floor of Orna Villa. Lights from lanterns and his bright experiments were often seen through the windows. He read late each night in his rocking chair.

Means died in 1883 at age eighty-two. Residents have since seen the lights and heard the squeaking rocker. When Wiley Folk St. John wrote "Ghost that Eats Biscuits" for the *Atlanta Journal Sunday Magazine*, published on October 13, 1946, Orna Villa was owned by Mr. and Mrs. E.S. Rheberg, who had purchased the home two years earlier. While preserving the historic core of the building unaltered, the Rhebergs added modern improvements, mainly in the bathrooms and kitchen. The ghost didn't seem to mind the changes.

The Rhebergs believed their ghost was that of Dr. Means's youngest son, Tobe, who argued with his father. While pondering his life's course, Tobe

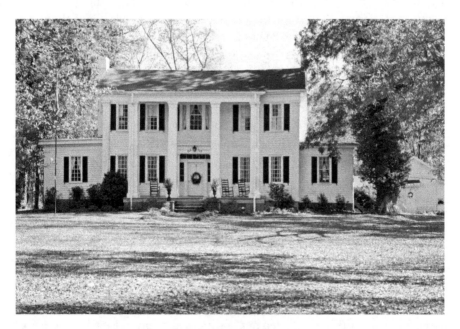

Tobe, the ghost of Oxford's Orna Villa, has vexed residents for 150 years. *Earline Miles.*

wore a path onto the boards of the back porch. At length, he elected to leave. After Tobe had been gone a while, one night the family heard his familiar heavy tread on the back porch. When he failed to enter, a family member threw open the door, but no one was there. No one was ever there when the footsteps resounded.

Tobe's repertoire included opening securely closed doors, rocking in empty chairs and pacing along the halls and back and forth on the back porch. After the kitchen floor was painted and the room locked down to dry, the Rhebergs discovered a man's footprint in the fresh paint. Toby performed one trick rarely attempted by denizens of the ghost world: he snatched food, sometimes cake but usually Mrs. Rheberg's biscuits, which would vanish mysteriously from the kitchen. For some reason, Tobe was heard to sigh heavily. "There's Tobe again!" the family would say and laugh after performances by the spirit. He was a good ghost and was accepted as part of the family.

The Rhebergs' daughter, Betty, returned one night from a date and went upstairs for bed. She let her parents know she was in, entered her room, turned a radio on low and relaxed for a while. She was in the process of turning the radio off when she heard someone she assumed was her father ascending the stairs. She called to him in a soft voice. Then the door to her room opened, and Betty screamed. There was no one visible at the door. Her father rushed in seconds later, but had seen no one in the hall.

Mrs. Paul Campbell of Atlanta was a granddaughter of Dr. Means and grew up in Orna Villa. She and all members of the family had experienced firsthand the footsteps on the back porch. A brother, convinced that someone was skulking about outside, once took a gun to confront the intruder. He found no one there.

At times, Campbell stated, a mysterious illumination filled Tobe's old room, making night bright as day. She witnessed the phenomenon herself. As for its origin, it could be another manifestation of Tobe or even of Dr. Means reminding the world that his work predated that of Thomas Edison. This had been not only Tobe's room but also Dr. Means's laboratory.

In 1967, the house was purchased by James and Glynora Watterson. "We just fell in love with its stateliness the very first time we saw it," Mr. Watterson told Beth Scott and Michael Norman for *Historic Haunted America*.

The new family converted the haunted back porch into a den and otherwise altered the home so it could be shared with his mother. Her residence was short, as she told James the house "hated her." Glynora also concluded that "there was something in the house that was against her."

Doors and windows were occasionally rattled by unseen forces, and a piano once motivated itself to play a tune without human accompaniment. James loved the new den and spent quiet hours in the morning and evening reading. "But sometimes I would see little things in the periphery of my vision," he confided. "Something would move. I was constantly noticing that." One night, "I happened to look up and the door to the parlor swung open. Every hair on my neck stood up. The parlor lights were off and I must tell you I was real hesitant to go in there. I did though and then all through the downstairs. There wasn't anyone around."

The ghost had a statement to make, apparently negative, about a collection that filled an entire room. Mr. Watterson had amassed an impressive collection of Civil War artifacts, including rifles, swords, uniforms and other material. "I had a rack of Civil War artillery muskets, seven or eight of them, hanging on the wall," he wrote, "with a long, glass showcase below it. I heard this terrible crash, and every one of those guns came off the wall. Fell right on the showcase." Each bracket had been wrenched violently from the wall, but the fragile, antique showcase was not scratched. Watterson re-hung the weapons, and the ghost never touched them again.

Watterson also had six Civil War–themed lithographs framed and hanging on a different wall. One day, all six lithographs simultaneously fell to the floor, but the covering glass and wooden frames were as unmarked as the showcase had been. Close inspection revealed that each hanging hook was intact; they had not simply fallen from the wall. It looked like they either jumped off or were dropped by ghostly hands, but gently.

Glynora had two troubling experiences in Orna Villa. She repeatedly had a strange dream in which she opened a door in the house and entered a room that did not exist, filled with lavish Victorian furniture. The vivid dream concerned her so much that James embarked on a survey to see if it could exist. "I carefully measured and drew the house plans," James said, "but I could always account for all but a few inches. So there was no such thing as a hidden room."

Tobe was next suspected of a murder most heinous. Glynora loved their pet, a yellow canary named Diana, which sang beautifully. The Wattersons planned a short out-of-state trip and left plenty of bird seed and a large container of water in Diana's cage, which hung from a wall by a hook.

After two days on the road, Glynora started having premonitions. "Something bad has happened to the canary," she told her husband. At home, they found the cage lying on the floor, broken by a fall when the hook

broke. Diana was found floating in the aquarium. Whether Tobe whacked the bird or it died seeking water, only the ghost knew.

The Wattersons loved living in an old house, but not one with a ghost that seemed to grow progressively more violent. They purchased another home, which they named High Point at Chestnut Grove, moved it to Oxford and sold Orna Villa in 1975.

James missed the old house, ghost and all. "I never felt a presence, or cold spots or a breath down my back or chill in my spine. It was a good house. It was a comfortable house, and most forgiving of anything we did to it."

In 1975, Dr. Terrell Tanner moved his medical practice to Oxford, purchasing Orna Villa as a home for himself, his wife and their six children. Asked two years later about the famous ghost by *Athens Banner Herald* reporter Jeanne Smith for an article that appeared on August 30, 1977, Tanner candidly replied, "He almost ran us out the first six months." Tanner and his family had heard the stories before they moved in but paid them little mind because of their strong religious beliefs.

The enclosed back porch became a family room, and a door joined it to a bedroom occupied by the Tanner's twelve-year-old daughter. She was alarmed when knocks were heard at that door and the door handle turned, all while no one was present in the family room. While Mrs. Tanner's parents visited and slept in that bed, they experienced identical phenomena.

The back porch pacing may have vanished, but door slamming increased. As the Tanners' maid worked alone in the house one afternoon, a door somewhere in the house banged violently closed, despite the fact that all doors and windows were secured and there were no air currents moving through the house.

While sleeping, the Tanners' sixteen-year-old son would get the feeling that his room was brilliantly lit, but when he opened his eyes, it had always vanished. The mother had also seen the light, literally, and stated that it was far brighter than any other light used to illuminate the house.

After a century of no actual apparitions, Mrs. Tanner was in the bedroom once when a man, described as tall and thin, walked past in the hall. She immediately called to him, but there was no stranger in the house.

The frightening weirdness also affected their younger children, the six-year-old twins of the couple and two five-year-old foster children. One night, one of the five-year-olds shook his father awake and asked, "Daddy, who's the man in my room playing with my toys?" The thoroughly alarmed parents searched but found no sign of the adult that had disturbed the child.

Supernatural stories usually accompany Georgia's isolated covered bridges, where travelers were bushwhacked by thieves and murderers. *Jim Miles.*

Several nights later, one of the six-year-olds entered the Tanners' bedroom and inquired, "Who is the man in my room?" Eventually, all four boys witnessed the man separately, but none was alarmed by his nocturnal visitations.

Dr. Tanner had experienced nothing until one bright afternoon when he was downstairs and saw the tall, slim man in the same hall where his wife had seen it. His careful observation provided additional details of the figure, which had long, reddish-brown hair and sideburns and wore a ruffled shirt, string tie and long coat. The man vanished instantly without paying Tanner any attention.

Tanner liked to think of the character as an angel. At the time, he was reading a Billy Graham bestseller, *Angels: God's Secret Agents*. That book and other reading affected his interpretation of the phenomenon, together with the facts that the figure had done nothing threatening and the four child witnesses had all been unafraid. Perhaps it was a guardian angel, but it was disturbing to the two older children. What course of action should he take?

"We claimed our heritage as children of the Lord," Tanner said. He prayed at the dining room table and in each individual room in the house,

asking that if the presence were a guardian, God would set his guard post outside the house and not disturb the family. If it were evil, Tanner prayed for his family's protection. "We have not seen him since," Tanner stated, and unusual phenomena recurred only once.

In 1984, seven peaceful, unhaunted years later, a Methodist minister and his wife stayed in the enclosed porch. When the Tanners came downstairs in the morning, they were surprised to find their guests drinking coffee in the kitchen. Both had been awakened two hours earlier, at 6:00 a.m., by a vigorous knocking on the door, but no one had been there.

Glynora apparently mellowed on the ghost of Orna Villa, saying, "Tobe lived there all those years, had a nice roof over his head, and now they're throwing him out. Well, I'm inviting him here." She addressed a note to Tobe from "A Friend" that read, "If you find Orna Villa no longer satisfactory, you have an invitation to visit High Point at Chestnut Grove. It's on Wesley Street. You can stay there for as long as you like….Mrs. Watterson said so."

"I felt so sorry for poor Tobe, that he had been exiled from his own house," Mr. Watterson told a reporter in 2010, "that we went out on the porch and had an anti-exorcism. We invited Tobe to come live with us since he was such a good ghost, and he's been here with us on Wesley Street ever since."

PEACH COUNTY

PERSONAL SPOOKS

F orgive me for throwing myself into these stories, but I have lived in this area for fifty-two years—my wife, Earline, for fifty-six years. We get around, and we have had some odd experiences.

In February 1972, after Earline and I left some youth church function (I remember because she was wearing a dress; the plaid one) in Warner Robins, we decided to explore central Georgia. We had heard that in Powersville, a community in Peach County, there was a large, old haunted house. We wandered about and found the structure, but it was brightly lit, with a number of cars parked outside, and we agreed that was not the right time for spontaneous ghost hunting. We continued to GA 49 and drove a short distance until we found a church at the top of a hill. We turned in and stopped.

It was a country church, a simple, single-room building with a cemetery in the rear. It was a bright moonlit night, and we circled the building, reading a dedication plaque and chinning up on the windows for a look inside. We meant no harm and were truly curious about the church's history.

Behind the church, we found a new slab of white concrete. Earline and I walked up to it, intending to read the inscription. As we stood there, a stream of gray smoke emerged from a corner of the slab. Stunned, we watched silently as a cloud formed and continued to expand. When the cloud began taking on a human shape, I tucked Earline under my arm, sprinted to the car, opened the door, threw her in, cranked it and raced for home, neither of us looking back.

A young couple in Peach County encountered a ghost in a church cemetery and later sensed that a suicide had occurred in a house. *Earline Miles.*

We returned the following day in bright sunshine to inspect the grave. The ground around it was solid, and the edges of the slab showed no holes. It was the grave of a man in his sixties who had died several years earlier. What the frightening apparition was, and what it wanted with us, are still mysteries.

I spent thirty years of my life teaching American history and government at Peach County High School in Fort Valley. I always said the community was like me—laid-back, old-fashioned and a little beat up. The name is a misnomer, as there was never a fort in Fort Valley. There were plenty of foxes, but the clerk who filled out the application for a post office had poor handwriting, so Fort Valley it became.

Besides peaches, Peach County is known as the home of Blue Bird Body Company, which over the decades has produced many of America's school buses, ironically painted yellow and not blue.

As a young married couple in 1977, Earline and I rented a house in Fort Valley on Troutman Avenue. Months later, we decided to buy our first home. There was a nice house down the street that was for sale, and we called the realtor and asked her to meet us there.

Earline and I walked to the empty house, admired the spacious porch and turned the front door knob. It opened, and we strolled into a large living

room, complete with fireplace. At first glance, the house seemed perfect for us, but in the center of the room, we simultaneously turned to look at each other. Without a word, we walked out and started down the sidewalk to the street, where the realtor was just leaving her car with that big salesman smile plastered on her face. "What happened in there?" I inquired, and saw her smile disappear.

"Who told you?" she asked in a whiny voice. Apparently, the property had been on the market for some time with no takers.

"Nobody," I replied. "We walked in and felt bad vibes."

Resigned, the realtor admitted, "The last owner hanged himself in the living room." She paused for a moment and then guardedly asked, "Y'all didn't actually *see* him in there, did you?"

We did buy a nice house from her on Forrest Drive and enjoyed five quiet, pre-children, unhaunted years there.

PIKE COUNTY

TAKE TWO EVPs AND CALL US IN THE MORNING

In 2012, a Zebulon family sought assistance from Ghosts of Georgia (GOG) for a haunting in their home. The family reported moving shadows, objects being shifted around the house, the sound of footsteps, flashing lights, photographed orbs and a baby being awakened and frightened in the middle of the night. There was also a video of the baby sitting on a rocking horse while the toy was pushed on the head by unseen forces. The family wisely discarded two rocking horses bought at a garage sale.

On May 5, 2012, GOG sent a team to investigate the affected home. The team brought two digital cameras, four IR video cameras connected to a DVR, five assorted EMF meters, four digital audio recorders and two fancy thermometers. I think Steven Spielberg made *Close Encounters of the Third Kind* with less technology.

The ghost hunters made a pre-inspection of the house, inside and out, and had EVP sessions throughout. Only one member of the expedition reported any experiences. She heard growling in one room, possibly attributable to dogs outside; banging in the bathroom that would not repeat; and whispers she believed originated from behind her.

The team "found no changes in the EMF or temperatures....We did not capture anything unusual in our pictures or video, and we did not record any audio anomalies. We also did not have any personal experiences indicating any paranormal activity in the house."

GOG concluded, "We do not believe that there is any paranormal activity in the home at this time but would recommend that the client keep a log if

they should experience anything they feel is of paranormal origin and call us back if they need us."

Personally, I'll go with the family reports of paranormal activity. I like to think that some spirits have grown tired of tech-heavy spirit investigators and sometimes mess with them by muzzling their antics during ghost hunts. I imagine them giggling their phantom asses off.

PULASKI COUNTY

MOTHER AND CHILD

The Sinyard House dates to the middle of the nineteenth century. Soon after the close of the Civil War, the family hired a live-in maid who had a child. They occupied a room on the second floor, where one day both were found murdered. As often occurred in those days, justice was never served because prominent property owners were rarely punished for crimes they might have committed against lowly workers.

Life continued normally within the house until recent years, when a new owner elected to extensively renovate the structure. That was when the history within the Sinyard House came to afterlife.

Footsteps thudded loudly on the stairs when no one was present. If clothes were left in heaps, residents returned to find them carefully folded and stacked neatly at the foot of beds. In particular parts of the house, a perfume, unlike any used by current residents, was scented. Sometimes a soft female voice was heard upstairs, like a mother singing lullabies to a child. Several times, people passing the house on the road have seen an unknown woman through windows in the second floor.

Once, while the owner worked on the house from a ladder placed on the first floor and leaning against the second, a force drew him to the top of the steps just before the ladder abruptly collapsed. It seems like the spirit of the maid remained, had no animosity for the current residents and needed to continue lending useful service.

Nor was she alone, according to Jackmc's blog. A child had been heard upstairs, playing, laughing and giggling at times when no children were in

the house. Poltergeist activity in the dwelling was also attributed to a playful child—doors slamming shut, items relocated around the house and things removed from kitchen cabinets. Shower curtains were abruptly pulled back while residents were showering. Perhaps the ghost child continues about its carefree play.

PUTNAM COUNTY

THE GHOST THAT ROCKED THE CRADLE

I t took considerable effort to locate a Putnam County ghost story that did not involve the famous spirit named Sylvia, but I did it. The tale originated in the November 12, 1933 issue of the *Atlanta Journal*. The story ranked third place among readers contributions and won Fannie Lee Leverette the princely sum of two dollars (remember, it *was* the Great Depression).

BRER RABBIT
BORN AND BRED
IN THE BRIARPATCH
HE SURVIVES FOREVER BY HIS WIT
HIS COURAGE AND HIS CUNNING

Mary Harris, mother of noted author Joel Chandler Harris, promised to return and rock a baby's cradle, which later moved "mighty mysteriously." *Jim Miles*.

Mary "Grandma" Harris, the mother of famed Georgia writer Joel Chandler Harris, was great friends with "Sister Jane" Conner. The women were also friends and neighbors of Leverette's parents and often gathered around their den fireplace after supper to socialize. Late one cold, winter night, Harris and Conner made a bizarre deal: "the first one to die would come back to earth." Both women adored all the Leverette children, but they were particularly enamored of the baby, Nona.

"Mary, if I am the first to go," said Connor, "I will come right back to this room and rock little Nona's cradle." Harris, with considerable spunk, replied that if she died first, "I am just going to come back and smack your sassy face and scare you out of seven years growth."

Jane was the first to depart this life, and Leverette's parents and Harris often saw the cradle rock "mighty mysteriously." "I saw that cradle rock many a time," Harris said, "but I can't see who did the rocking, for you couldn't see anybody near."

Leverette's mother testified that, many times, "way in the night when I would hear Nona's cradle begin to rock, I would feel impelled to reach out and slip her into bed with me, but instead I would tuck my own head down under the covers."

Grandma Harris was convinced that Sister Jane was concerned about something that involved a feather pillow. She obtained permission from Leverette's mother and father to examine a pair of feather pillows that Jane had left there when she was taken to the hospital. Inside one pillow, she found a cloth pouch labeled, in Jane's handwriting, "For Baby Nona." Within that pocket was seventy-five dollars in gold and silver coins. It was said that the cradle never rocked afterward. In 1933, the pillows remained in the Leverette family.

RICHMOND COUNTY

ONE OF MANY ARSENAL GHOSTS

The United States Arsenal at Augusta was moved in 1826 from an unhealthy location along the Savannah River to its present site. It was active during the wars against the Seminole Indians in Florida, the Civil War, the Spanish-American War, World War I and World War II. When the arsenal was closed in 1955, the property became the campus of Augusta College, now Georgia Regents University.

Dr. Ed Cashin, who once taught history at Augusta College, is author of *General Sherman's Girlfriend and Other Stories about Augusta*. Cashin's favorite ghost story involved Emily Galt, who at age twenty-one inscribed, "Emily Galt, 1861" onto the window glass of Bellevue Hall (1820), the school's oldest building, constructed in the impressive Sand Hills style by Freeman Walker, Augusta mayor and a U.S. senator. Emily and her sister, Lucy, were daughters of James Galt, an arsenal employee who lived there. According to this story, of a type related throughout the South, Emily Galt had become engaged to a young soldier and used her diamond engagement ring to engrave the inscription. Galt and the fiancée had argued about his going to fight in the Civil War, and inevitably, he was killed in combat. Disconsolate, Galt threw herself through the open upstairs window, where she had carved her name, and died. For decades, night employees have heard Galt and her soldier argue loudly, but searches never reveal any tangible or living persons.

Ginny Luke, a building employee with more than fifteen years of experience, knew of "people in the building by themselves and they've heard two people arguing." She witnessed a television set turn itself on and

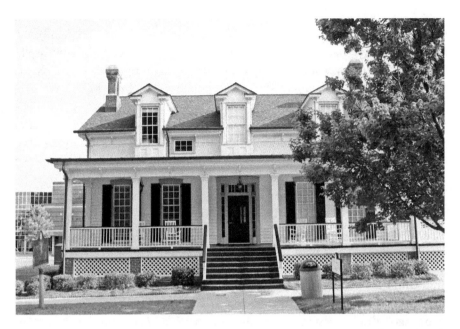

Ghosts regularly manifest themselves at the old U.S. Arsenal in Augusta, now the campus of Georgia Regents University. *Earline Miles.*

Textile mills were dangerous places where workers were maimed or killed, commonly resulting in ghost stories. This is Sibley Mill in Augusta. *Author's personal collection.*

off repeatedly. "Right outside my office was a TV," Luke told Kimberly Lawson of *Augusta* magazine. "At odd times, it would come on by itself. Once, I reached over and turned it off and it came right back on." Near Halloween, 2002, she caught the spirit watching *The Today Show*. "We like her as a friendly ghost," Luke concluded.

Another employee, Tiffani Jones, has personally heard footsteps on the stairs and whispers from an office when no one else was present. Emily also apparently messes with the phone system, which occasionally goes berserk, although the phone company always checks and never finds a problem.

Dr. Robert Mays, director of counseling and testing, heard of a construction worker who "said he wasn't going back in there [Bellevue Hall] at night anymore. There were too many strange things. Doors opening and shutting." This brings up a thought: if ghosts can move effortlessly through physical barriers, why are they so enamored of opening and closing doors and windows? Old force of habit?

For safekeeping, the inscribed window was removed and stored several years ago. Emily's sister, Lucy, also left her name on the window, but apparently she met a kinder fate and moved on into the afterlife.

A competing story has the daughter of the Confederate commandant falling for a soldier. The father reacted to the beau's request for permission to marry with a transfer to combat, where he was killed.

Bellevue Hall, Georgia Regents University, is at 1120 Fifteenth Street Augusta, GA 30912; http://www.gru.edu.

SCHLEY COUNTY

MR. LARKIN'S FEIST DOG

A feist is a small hunting dog, the result of crossbreeding other hunting canines in the rural South. George Washington and Abraham Lincoln both wrote of this unique breed.

In 1862, fifteen-year-old Aron M. Larkin acquired a vocal feist that he named Yip Yip for its signature bark. They were constant companions while hunting in the woods. When Larkin was ready to quit at day's end, he would summon his trusted friend by yelling, "Yip Yip, come home!" The faithful dog always responded, the sounds of his "yip, yip, yip" getting closer and closer.

When Larkin took up the Confederate cause, he entrusted Yip Yip's care to family members. Larkin fought with Company H, Tenth Georgia Infantry. Upon his return after the war concluded, Larkin was heartbroken to learn that Yip Yip had disappeared. Larkin died in 1923 at age seventy.

Robert L. Wall is magistrate judge in Schley County. He was hunting in the fall of 1986, sitting quietly in his deer stand as the day passed. When the sun was setting and darkness was enveloping the woods, he knew it was time to go home, yet he lingered a little longer. "But as I sat there I could hear the faint bark of a small dog, 'yip, yip, yip,'" he wrote. "It seemed to be calling someone to come to it. As I sat and listened I wondered who might have a small feist dog that would be barking after dark."

On the following afternoon, Wall asked his father if he knew who might own such a dog. "He looked at me with a sly grin and said that it was old man Larkin's dog." Daddy Wall told him the story. As time passed, "on different

occasions you could hear the faint call of a male voice calling, 'Yip, yip, come home!' In the background you could hear the 'yip, yip, yip' of a dog."

Thanks to Pam Register, Schley County tax commissioner, for finding this story, which turned out to be the last of 161 tales needed to complete this book.

SCREVEN COUNTY

THE CHURCH AT SIX BRIDGES

In decades past, Six Bridges was a tiny community in rural Screven County, a collection of houses and a one-room country church. Sundays would find nearly everyone in the rustic, unpainted church, worshipping and singing hymns joyously.

The village could not support a store, so all the locals traveled to nearby Hilltonia to shop. Inhabitants of the two settlements enjoyed a friendly relationship, and concern grew in Hilltonia when residents realized that no Six Bridges citizen had appeared in town for some time. An expedition was quickly organized to check on the welfare of their neighbors.

The small troop of mounted men trotted down the narrow wagon track through thick forest. Emerging from the woods, they found Six Bridges quiet, seemingly deserted. The men knocked politely at the first house. Then, when there was no response, they gingerly opened the door and entered but found no one home. The same situation was found at several additional homes. Growing more apprehensive, they thought that perhaps everyone had gathered in the church for a town meeting.

The men trod carefully onto the crude steps and short porch before slowly opening the doors of the sanctuary. As related in an account posted on the Southern Hauntings website: "There was the entire town, neatly seated in the pews and the preacher at the pulpit...all dead. There were no wounds, no signs of conflict, just the decaying bodies sitting with hymn books open." The Hilltonia men buried the citizens of Six Bridges beside their church. No cause of their deaths was ever discovered.

The last remains of a vanished home or community are usually lonely chimneys. The cursed community of Six Bridges was reclaimed by nature. *Earline Miles.*

Georgia has many "magic hills," where invisible beings appear to push vehicles up an elevation. Some stretches of these roads remain. *Earline Miles.*

Superstitious dread prevented anyone from moving into the cursed town, which was studiously avoided by most. The trail to the village became choked with undergrowth, and one by one, the houses decayed and collapsed. The church lasted some years longer before yielding to entropy.

Six Bridges was truly a ghost town, in two different contexts. The story was known throughout Screven County, and every young man was challenged to visit the site and venture into the church. Many boys yielded to the dare and entered the village, but few had the nerve to peek into that church.

The author of this tale was one of the brave few who "walked up the rotting steps and across the porch of the church. When I pushed open the door I saw a sight that remains burned into my mind even today. There were the people of Six Bridges dressed in their Sunday best, and the preacher standing at the podium. He looked up and right into my eyes with a cold, mournful look. His face was full of sadness and the eyes as black as coal."

SPALDING COUNTY

A BARFLY GHOST

Soon after Cherie and Jimmy Jackson opened a restaurant in an old building in downtown Griffin, they experienced paranormal activity. One Sunday, Cherie spent three hours alone at the restaurant preparing for Monday's business. When she was leaving, "I heard what sounded to me a male voice speaking my name in a whisper," she wrote in a report for the Foundation for Paranormal Research (FPR). She immediately exited the building and described the incident to her husband, who "started telling me things that had happened to him."

At the entrance, patrons could go downstairs to the bar or into the dining area, and the light switches for both areas were mounted by the door. Jimmy often unlocked the restaurant to find the lights on, even when he knew he had been the last person to leave and had extinguished the lights. Cherie confirmed this phenomenon, but only the bar lights were left burning for her.

One night, Cherie noticed a man in the bar before it opened. Turning toward him, "he was not there. Since that time, while being downstairs I have on numerous occasions, caught something out of the corner of my eye."

Several days later, Jimmy reported that the doors between the kitchen and dining room had slowly opened and closed by themselves. "These doors are heavy and swing shut almost immediately," Cherie wrote. "It is almost impossible to manually make them move slowly. Jimmy has even felt as if someone were breathing on his neck." An employee witnessed the door phenomenon with Jimmy, and both would later see it repeatedly.

Another worker in the bar heard singing and laughing, and yet another employee, according to Cherie, "experienced on several occasions a presence while sitting downstairs alone." Once, when the staff was discussing the ghostly occurrences, "there was a loud crash from the kitchen," Cherie stated. "Everything on one shelf, which held baking pans, etc., had fallen to the floor."

TALBOT COUNTY

DOUBLE-BARRELED REVENGE AND OAK TREE JUSTICE

N early 120 years ago, Talbottom dentist Dr. William L. Ryder sought the affections of Miss Sallie Emma Owen. However, she ultimately spurned his affections for a local attorney, Mr. Gus Persons. On Easter Sunday, April 5, 1896, Sallie and Gus sat on a couch before a fire in the parlor of Jennie Beall McCoy's house, enjoying each other's company. Dr. Ryder stormed into the house with a double-barreled shotgun and discharged each barrel into Sallie, killing her instantly.

Dr. Ryder's trial lasted two weeks. After a short deliberation, the jury returned a verdict of murder. Ryder was sentenced to be hanged, but the Georgia Supreme Court overturned the verdict on appeal and a retrial was scheduled to begin on July 19, 1897, in Columbus. When that trial was delayed for several weeks, the passions of local citizens took control of events.

Ryder was imprisoned in Waverly Hall while awaiting transportation to Columbus, guarded by Talbot County deputies. A vigilante mob wrestled control of Ryder from the law and hanged him from an oak tree between Waverly Hall and Talbottom.

The McCoy House, scene of the infamous crime, still stands, according to *Talbottom New Era* columnist Joey Loudermilk in the October 14, 2005 issue. "There are still stains in the floor boards where the blood of Miss Sallie Emma Owen oozed through the carpet on that fateful Easter Sunday so long ago," Loudermilk wrote. Further, the current owner of the property, Mrs. Maxwell, "claims the house is subject to paranormal activity (strange knocking sounds, doors opening by themselves), and believes she woke up

Sallie Emma Owen, murdered by a spurned suitor in this house, shifts furniture, knocks on walls and trods the halls. *Earline Miles*.

This is the battlefield of Griswoldville, where a force of boys and old men was decimated. Such spots are usually paranormally active. *Earline Miles*.

one morning and saw the ghost of Sallie Emma standing next to her bed. Perhaps *those* walls are indeed talking," Loudermilk mused. Also reported are footsteps roaming the hallways and the mysterious shifting of furniture.

On October 8, 2005, the community hosted a reenactment of the county's most notorious trial in the original courtroom. Wearing period dress, local lawyers and judges played roles, and Gus Persons was portrayed by his great-great-grandson. Dr. Ryder was dutifully convicted and sentenced to death. The real Dr. Ryder has not been heard from since 1897, but Sallie continues to make her continued presence known.

TALIAFERRO COUNTY

FACES ON THE CEILINGS

After Deborah and her family finished a tour of duty in Germany in the 1990s, they purchased the Asburg estate and were excited to raise their children on a farm. Deborah stripped decades of old paint from the heart pine floors, mantels and other features. Then they turned their attention to the exterior, removing paint and additions not original to the house.

Although they left carpeting in upstairs rooms, when Deborah worked alone in the house, "I would hear heeled shoes walking on hardwood floors from bedroom to bedroom." Her calls of "Who's there?" went unanswered.

During a Christmas dinner with friends, she heard a loud crash. In the dining room, Deborah found her empire card table pulled apart, an antique coffee/tea set scattered across the table and the Christmas tree fallen across the table. A rubber mallet hammer was needed to restore the dovetailed table. There was no explanation for the havoc, but Deborah later learned that one of her guests that night "was clairvoyant, and this may have met with some disapproval by our spirit[s]."

The most frequent and disturbing phenomenon "were the faces that would show up in the ceiling corners within the upstairs bedrooms at night particularly in the boy's bedroom." To reassure the children, Deborah told them, "Those were angels watching over them to protect them from evil."

TAYLOR COUNTY

FURNITURE KNOCKING LIBRARY GHOST

In October 2006, I was asked to speak to the Taylor County Historical Society, which met at the Butler Public Library. It is a very active organization, and the meeting room was packed as I unloaded my books and set up a table. In the entrance to the building, I noticed an unusual piece of furniture for a library: an old-fashioned hutch, beautifully restored and displayed, which sat opposite the door to the meeting room.

I spoke for half an hour or so, talking about ghosts, and the cabinet didn't make a sound. However, everybody was smiling and nudging one another and saying, "Just wait." Then the hutch started banging away at me, and the congregation had a good laugh. It was an amazing and well-known local phenomenon.

The haunted cabinet has its origins with Annie Laura Edwards, who was born just months before her father, prominent Butler attorney William Posey Edwards, enlisted in the Confederate army in October 1861. While serving with Company F, Twenty-Seventh Georgia Regiment, he was captured at Antietam and imprisoned in Baltimore before being exchanged. He suffered a serious wound at Ocean Pond, Florida, better known as Olustee, and the war ended as he convalesced in Butler. He had also seen combat at other fierce battles.

In January 1888, Laura Edwards married James E. Davant, a local judge. The couple had six children, with two dying in childhood. Surviving were daughter Hortense and three sons.

The deaths of Laura's father and another local prominent Confederate veteran, Colonel William Sharp Wallace, inspired Laura to organize the

Wallace-Edwards Chapter of the United Daughters of the Confederacy (UDC), in which she served as president and vice-president. She led the efforts to purchase and dedicate the Confederate monument that stands on the Taylor County Courthouse square and organized a yearly celebration on Confederate Memorial Day. Mr. and Mrs. Davant were active members of the Butler Methodist Church, and she served as president of the Women's Missionary Society for years.

In about 1920, the family left for the oil fields of Texas, earning a fortune in petroleum and land, but they returned to Butler for long visits. When Laura died in December 1935, her remains were returned to the Methodist church cemetery in Butler and buried with her husband and children.

James Robert Wilson was a skilled woodworker with a widespread reputation. Known in Butler as Mr. Rob, he constructed a rocking chair specifically for President Franklin Delano Roosevelt that today is preserved at the Little White House in Warm Springs.

The library hutch is a superb example of Wilson's craft. It is a unique combination of a secretary and a china cabinet; the upper portion features double glass doors, while the lower half has wooden doors with a set-in lock. Separating the sections is an open display area. A bronze plaque reads, "In Memory of Mrs. Laura Edwards Davant."

This hutch in the Butler Public Library is haunted by Anne Laura Edwards, who energetically knocks on the cabinet. *Earline Miles.*

The hutch was long utilized by the Butler Garden Club for storage of records in the Butler Community House. When the garden club sold the building, the cabinet was sent to storage. As a new structure for the library was opened, the cabinet was restored and displayed. Since the library's dedication, the cabinet has often greeted "patrons with a loud thump, as though someone had rapped his knuckles on the wood," wrote local historian Sybil Willingham.

The hutch was the property of Miss Laura, Willingham explained. "We say when it starts knocking and makes all kinds of noises that Miss Laura does it and

she is not pleased with what is happening. It is true that it makes all kinds of noises all the time. One day a lady wanted to look at some records we kept in there and when we unlocked it, it started making all those noises and she said, 'Well, maybe I better not look at 'em.'...People wouldn't believe it if they didn't hear it," Willingham wrote.

The common belief is that Laura's spirit resides in the cabinet and speaks up in the only way available to her. The Wallace-Edwards Chapter UDC assembles monthly in the meeting room across the hall from Miss Laura's cabinet. The door is customarily left open, and when an important issue is pending, "There was often a thump from the cabinet when the vote was called." Miss Laura, although absent in body, still casts a ghost ballot.

Laura also seems to object to noisy modern cleaning technology. When a vacuum cleaner is employed, she registers her complaints with loud thumps. According to Willingham, Miz Johnnie, the Taylor County librarian, does not believe in the haunted cabinet. "This is ridiculous!" she exclaimed when the subject was raised. "There are no such things as ghosts."

However, something happened when Willingham asked Miz Johnnie to get some garden club records from the cabinet to assist her research. She kindly agreed, but when Willingham checked back to see if she had retrieved the documents, Miz Johnnie replied, "No! I started to open it. I put the key in the lock and it growled at me! I am not going back out there. You can take the key and get the records if you want to, but I am not about to!"

Willingham took the key to the cabinet and had a kindly chat with Miss Laura, asking permission to unlock the cabinet, remove the records, treat them gently and return them to the cabinet. Willingham experienced no trouble in this endeavor. To keep on the spirit's good side, "I never enter the library without greeting Laura," she said.

Butler Public Library is at 56 West Main Street, Butler, GA 31006; (478) 862-5428.

TREUTLEN COUNTY

DIRTY OLD PREACHER MAN GHOST

I have striven mightily to find ghost stories from every possible source, and I positively giggled when I stumbled on this one, straight from that periodical of journalistic excellence, the *Weekly World News*, of August 16, 2004.

A faithful reader called "Christian Woman," of Soperton, Georgia, wrote to "the Psychic Shrinks"—the Sabak sisters, Serena and Sonya, who were touted as America's sexiest psychics—about her paranormal problem. The *Weekly World News* ran a typically subtle headline: "Preacher's Ghost Sneaks into My Bedroom at Night."

Christian Woman addressed her problem to Serena. The minister in question had died earlier in the year in an automobile accident. However, she believed that he had not reported to the celestial realm "because his ghost creeps into my bedroom every night, watches me undress, and makes love to me with his eyes."

The problem had grown so severe that Christian Woman had begun sleeping in her clothes "because I'm embarrassed for Reverend's spirit." She explained that this behavior might have been acceptable had the preacher been single in life, but he had been married at the time of his demise. She remembered that the minister "often preached about the sin of adultery. But his ghost is a voyager." She feared that the clergyman might tire of mere "'watching,' and try for more. Help!"

Serena, slightly rudely, replied that the minister "is sowing a few wild oats before he accepts his final reward in Heaven." He was attracted to Christian Woman because her "reputation as a hussy led him to believe you wouldn't

mind his indiscretions." The psychic wrote, "Now that he knows you're offended, he won't bother you anymore." The preacher man had informed Serena, "I thought she would enjoy it. I apologize and tell her I'll see her real soon in Heaven." He explained that she would soon die in her own car crash, but she should not worry, because "your passing will be both instant and painless."

TROUP COUNTY

SWINGING GRANDMA

K athleen Cumber grew up in West Point, next door to her beloved grandmother, whose favorite place was a swing on the front porch. Cumber grieved when her grandmother died in 1926. Several years later, during the summer of 1930, Cumber was passing her late grandmother's house when she glanced at it and saw her grandmother on the front porch, quietly swinging. Cumber was not surprised by the sight, for "it seemed the natural thing." As she had done so often, "I waved and said, 'Hello,'" The woman vanished instantly and the apparition never reappeared, but Cumber longed to see her again.

TWIGGS COUNTY

THE OLD GHOST-FILLED HOTEL

The town of Danville was once a thriving community, energized by the trains that brought commerce each day. The hub of activity was the Danville Hotel, constructed in about 1887. When the locomotive traffic ceased, so did bustling Danville, replaced by a quiet residential community.

The hotel became known as the Leverett House. It still stands beside the railroad tracks, just off U.S. 80. Locals count upward of fifteen deaths in the building, all allegedly from murder or suicide, and long ago the structure gained a notorious reputation for being haunted.

In the November–December 1989 issue of *Macon* magazine, Paige Calvert Henson described the experiences of the family of Roberta and John Burch, from Macon. They moved into the Leverett House in June 1982, renting with the expectation of eventually buying. Their residence lasted only four weeks.

As Roberta was organizing her kitchen, she suddenly detected a strange breeze blowing on the back of her neck. No doors or windows were open, and a wind current seemed unlikely. Turning from her washing machine, she spotted a young man, with blond curly hair and dressed in farm clothes, emerge from a breakfast nook only a few feet from her. The figure stepped through the door and evaporated.

Afterward, the Burches began to feel an evil presence in the house. As part of their renovations, John pushed all the furniture in an upstairs bedroom into the center of the room and painted the walls. Finished, he went to bed in the master bedroom, located immediately beneath the newly painted

Old wooden houses are decaying along every Georgia highway. Some are haunted, while all are reminders of past lives. *Earline Miles*.

space. Hours later, he and every member of the family were rousted from sleep by the sound of furniture being shoved around the second-floor room. The family awaited sunlight to investigate and found the furniture lined up against the walls of the repainted space.

Events in the house became uglier. The children dreamed of heads rolling down the stairs, and locked doors were found unlocked, while other doors slammed shut from no discernable cause. In the middle of one July day, Roberta suddenly became unaccountably sleepy, as if drugged. She fought the sensation but retired to the master bedroom and fell onto the bed, mightily begging God for divine help in this trauma. She awakened some twenty minutes later, frightened and still groggy. Beside her on the covers was an impression of a sitting person. That presence began to move, getting up, and the sound of a woman's footsteps were heard walking across the room.

The nightmare intensified. Immediately after the departure of the phantom woman, a thunderous noise, sounding like a troop of booted soldiers crashing rifles simultaneously on the floor, resounded from the upstairs vestibule. The "soldiers" started down the stairs, stopping outside her bedroom. Roberta buried her face in her pillow, resolved to not look

up no matter what happened. She heard a single figure enter the room and stop at the edge of her bed. After a moment's pause, it left the room, and the entire complement of stompers exited the house and pounded across the porch. The Burches left with no hesitation.

In 1989, the Leverett House was occupied by Penny Harris and her four children. She knew the history of the house, but after eight months' residence, all she could report were locked doors found unlocked and slamming doors. However, she also sealed off the entire second floor, apparently giving the haints their own space.

UPSON COUNTY

THE BLUE LADY OF HAGAN'S MOUNTAIN

In her nonfiction eBook *The Blue Lady of Ada'hi*, Libby Moore described how she and her husband, Lee, bought thirty acres of timberland on the side of Hagan's Mountain, which peaks at 1,200 feet six miles from Thomaston. She explained that the local name of the elevation was Indian Grave Mountain for Native Americans who occupied the site centuries ago and buried their dead in graves and mounds that remain. Their spirits "still roam the peaceful land," she stated.

The Hagan family owned most of the property for generations, the wilderness hiding numerous stills that produced moonshine. Disputes between moonshiners and customers and family squabbles claimed victims, and "the spirits of these people roam the peaceful woods also."

The Moores dubbed their tract Ada'hi, a Cherokee contraction for "beautiful spot in the woods." They planned to eventually construct a house and make the forest their permanent home. The family trekked across the land and chose a spot near a stream for picnics. There Lee started to clear land, spending weekends with "ax, ditch blade, pistol, some beer" and other necessary items. Libby and their children would join him for lunch.

As Lee worked one day, their dog, Ming, "suddenly raised up, growled softly, and headed toward the road" but soon stopped and lay down. Looking in that direction, "in the distance [he] saw a young woman standing almost behind a tree. She was wearing a blue tattered dress and was barefoot." When he noticed her, she "quickly stepped behind the tree."

Death and misery occur in every hospital, but a few develop a reputation for intense hauntings. *Jim Miles*.

Believing it was Libby being playful, Lee returned to work and then glanced back and saw the Blue Lady "behind a different tree." At his gaze, she again stepped behind the tree. Now uncertain of her identity, Lee returned to work. About twenty minutes later, when Ming growled again, he looked up and found her "standing behind another tree much closer." The mysterious lady "motioned for him to come to her."

Knowing that it wasn't Libby, he thought she might need assistance and walked toward her. The figure was motionless until he was fifty feet distant, when she "once again stepped behind the tree." He ran forward but found no trace of her. After describing his experience at home, Lee was teased. The Blue Lady made regular appearances, but only to Lee. He never caught more than a glimpse, and she never beckoned to him again. Lee never located a physical trace of the elusive figure.

A year after their purchase, Lee had cleared trees for a road, and they chose a house site, a small rise with evidence of a previous residence. They installed a used mobile home with electricity and telephone, but their water came from the stream. The family packed for weekends at Ada'hi, and after work and school, they would occasionally spend the night before hurrying home to prepare for the next day.

The Blue Lady continued periodic appearances to Lee, and a new phenomenon occurred. At a rough, sharp bend in the road near their home, Lee "would catch a movement out of the corner of his eye" but never saw anything directly. He also felt he was being watched.

One evening at dusk, Lee left the mobile home and "immediately felt the presence of something." At the road bend, he saw an "indistinguishable object and a foggy mist." He got his pistol and dog and started toward the phenomenon. Ming growled, her hair stood on end and she turned back. Lee observed the bend for several minutes but detected nothing.

A friend, Kenneth, volunteered to put a security light on a tree at the curve. The day after completing the task, as he and his wife drove to the mountain, he declared, "I'm never coming up here alone again!" As he had worked, he felt a presence watching him, but all he saw was a movement from the corner of his eye. "That placed is haunted," he told Libby and Lee.

One evening, while shucking corn in the back of their pickup truck, Libby caught sight of a motion near a tree at the security light. Lee noted the change in Libby. "You saw it, didn't you?" She nodded her head, and Lee said, "I saw it too."

As Lee worked the garden at the house, he heard a baby cry. He tried to ignore the sound, but it recurred, "so clear that he was quite positive a baby or small child was at the security light." Lee walked seventy-five feet down the road but heard nothing. Turning around, "the baby cried again!" but closer to the mobile home. Reaching the residence, the sounds ceased but started again near the site of their future home. He started in that direction, but the cries stopped as the phone rang. It was Libby, asking when Lee would be home. Libby knew that he was rattled, and he finally explained. Libby decided that her call was providential, saving Lee from whatever was summoning him.

Four years after obtaining the land, the Moores purchased a sixty- by twelve-foot mobile home and placed it beside the homesite. A well was dug, and the family moved in to the cramped quarters. Nothing happened for a while, but the Blue Lady made her final appearance, fifty feet into the woods, partly shielded by a tree. She had never been so close and stared for a minute, still clad in the same tattered blue dress. "She raised her arm as if in a good-bye wave and faded into nothingness."

In 2010, the family moved into their new, spacious, three-story house on Hagan's Mountain. One night, the Moores' daughter, Kathy, returned from visiting a friend five miles away. She related that her friend's mother "asked her if we had ever seen the 'Lady in the Woods.'" The woman explained

Long avenues of old oaks mark the entrance to former plantations, sometimes haunted by the workers who lived, toiled and died on the land. *Earline Miles.*

that the lady was the young wife of a Hagan relative who "either committed suicide or had been killed on Hagan's Mountain many, many years ago." She admitted that many locals knew of the lady, and some had sighted her, "but few would talk about her to outsiders." When Kathy asked what the lady wore, the reply was, "A pale blue torn dress."

Only a few weeks before Libby wrote her account, Lee woke up her at 3:00 a.m., saying, "We definitely have a haunted spot on this mountain—I think they are trying to get to me." Libby realized that most of Lee's sightings occurred at the tree/security light, as had hers, and the baby crying started there. Although the well digger had been directed to drill at one spot, he dug near the security light. Lee transported stones from the original site of the Blue Lady's appearance for a flower garden at the light. While unloading them, "the truck started rolling for no apparent reason." Lee was nearly crushed between the truck and the tree. While putting a roof on the pump house, he fell backward off a ladder and was totally incapacitated. Then a nearby tree died suddenly and fell, destroying the security light. A year after this, lightning struck the light. The light would never function again. "Once again that area is clothed in darkness. Perhaps the spirits like it better that way!" Libby thought.

Two months before Libby wrote the story, Lee was returning home late at night. At the curve, "the steering wheel was torn from his hand," and the truck crashed head-on into the security light tree. Lee said "something definitely jerked the steering wheel out of his hand!"

Libby concluded that the Blue Lady believes Lee is her husband or a ghost intended to kill Lee, knowing "that the kids and I could never manage thirty acres alone," seeking to drive them off the property through his demise. Four months after completing her book, Libby decided that a spirit "moved into our third floor." One night, with Lee and Kathy asleep and son, Danny, absent, "I hear it moving around in Danny's room." It subsequently occurred on other occasions. "I know it does not do any good to go up and look for it because it only moves up to the attic when I approach," Libby wrote.

When Lee mentioned that the ghost had moved in, she laughed and said, "Yes, I know." So far, it had only walked around the house, and that didn't bother the family. However, a repairman, working alone one day, left the house before the job was completed after he heard footsteps in the "empty" house.

The Moore family never felt threatened, and they loved their home on Hagan's Mountain, their Ada'hi. The ghost of Hagan's Mountain has many variations, as befits a purely local phenomenon. On Ghosts of America, Casey reported that several years earlier, she and several bored friends drove to the summit, turned the car and headlights off and rolled the windows down. A few minutes later, "It sounded like a woman was screaming far away in the woods. It was so scary."

She heard that at some point in the past "a woman was hung at the tower on top of Hagan's Mountain. That must have been her." In the vicinity is Boy Scout Camp Thunder, whose resident spirit is reportedly a blue woman named Midnight Myers.

Buy a copy of *The Blue Lady of Ada'hi* at https://www.smashwords.com/books/view/171799.

WARREN COUNTY

GHOSTLY ACTIVITY THROUGH WITCHERY?

In the 1820s or 1830s, according to an account originally printed in the *Augusta Chronicle and Sentinel* and republished in the *Savannah Daily Morning News* on April 21, 1857, there lived in Warren County a witch, designated as Mrs. A. She gained that reputation, the news item related, "on account of the personal appearance—as she was anything but handsome—or because of her peculiarities or eccentricities of character....The story was pretty generally credited, and she was generally feared and avoided."

Living in that area was a good Christian woman recorded as Mrs. C. She, her farmer husband and their several children were all highly regarded in their community. Despite the frightening reputation of Mrs. A as a witch, Mrs. C befriended her and her husband, who were destitute. Mrs. A was a regular visitor to the Cs' house, returning to her hovel with food. The As particularly enjoyed weekly donations of buttermilk.

However, as one summer progressed, the buttermilk supply diminished, and that contribution was halted. For some inexplicable reason, this apparently caused Mrs. A to strike out against Mrs. C's family.

One day in early August, Mrs. C's children were gathering peaches in their orchard when they were summoned for supper. The kids immediately complied, except for Susan, age nine or ten and described as "sweet-tempered, docile, and very intelligent," as well as adored by her parents and siblings. When she finally dragged herself into the house, Susan "appeared dull and stupid" and resisted her parents' directions. She refused to take her place at the table until repeatedly told.

"As soon as she became seated," the account related, "with a wild expression, and in a hurried, nervous manner, she stretched out both hands and began to rake the contents of the nearest dishes into her plate." The family was shocked by her conduct. Before they could react, Susan "went into violent convulsions, screaming in a wild and excited manner, that Mrs. A, the reputed witch, was present and endeavoring to beat her."

After a minute or so, Susan recovered, becoming "as conscious and rational as she ever was." The girl explained that "she had seen Mrs. A in the peach orchard, and that the old lady had unmercifully attacked and whipped her." When the alarmed parents examined her body, "she was found cruelly marked, as if with a switch or whip." When questioned, the other children had not seen "Mrs. A, or noticed anything uncommon in [Susan's] conduct whilst in the orchard."

Unfortunately, Susan soon relapsed, going into "spasms, screaming as before, that the old woman was there and wanted to whip her." For the next three weeks, "there was a constant recurrence of these scenes, and it was painful in the extreme to witness her suffering, and hear her call, without avail, upon her father and mother and every one present to protect her. The interval between the convulsions were of short duration, and never afforded any ease or quiet, as she was always excited and in the greatest trepidation, lest her tormentor should appear and do her some bodily injury."

During this period, many people, some traveling from up to twenty miles distant, came to witness "the mysterious circumstances." One morning, a visitor noticed the back of the chimney, "thickly covered with impressions, resembling somewhat a colt's tracks," outlined in soot (hooves are often associated with Satan and witches). Mrs. C was aware of the situation, as she swept the impressions away every morning, but they always reappeared by night. Other visitors corroborated the phenomenon.

One day, in the presence of numerous witnesses, Susan was unusually afflicted, terrified and trembling. She threw herself into her mother's arms, "with the utmost horror depicted upon her countenance—shrieking at the top of her voice that the old woman was in the room."

Susan pointed to a chair fifteen or twenty feet away from anyone present as Mrs. A's location. Suddenly, that chair "began to rock back and forth, and finally turned completely over, and in an instant it again assumed an upright position." A moment later, a knife, which Mrs. C had been using to pare peaches, "leaped from her hand and fell several paces distant."

Although Mr. C had never believed in the supernatural before, the condition of his child challenged his faith. He refused the advice of some—

to kill Mrs. A—but he did compel her to come to the house, where he demanded that she say, "God bless the child." However, all the alleged witch uttered was, "My God bless the child." It didn't work. "After three weeks intense suffering, and untold anxiety and wretchedness on the part of her parents, the beloved daughter died."

The newspaper correspondent acknowledged that "the facts are very strange, and will no doubt appear incredible to many, but they are nevertheless true, and could be substantiated…'by a crowd of witnesses' as respectable and veracious as would be required for the establishment of truth."

WASHINGTON COUNTY

A GHOST THAT SLIPPED AWAY

B ryant Watkins was a respected and prosperous citizen who lived in an old house near Sisters Baptist Church, two and a half miles from Sandersville. In 1834, he was a second lieutenant in the Washington County Militia, and in 1863, his beloved son was mortally wounded at Chancellorsville, Virginia, where Thomas "Stonewall" Jackson also met his fate. Watkins frequently served on the Washington County Grand Jury, was superintendent of a smallpox hospital and was an officer at his local Masonic lodge.

Elizabeth, Watkins's first wife, died at age seventy in 1884, and the following year, he married Mrs. Martha Martin. His death in 1893 provoked the revelation of ghostly events at his old home that may be traced to Elizabeth's displeasure with Martha's presence in her home, a tale reprinted in the *Savannah Morning News* of September 15, 1890.

In the period before his death, Watkins was faithfully attended by a daughter, whose name was not disclosed. As a gift, she was presented with two new underskirts, described as "beautifully embroidered." When Bryant Watkins died, the daughter decided to wear one of the underskirts to his funeral.

A large crowd of family and friends followed Watkins's horse drawn remains to the family plot at Sister's Church. "While the daughter was bowed in sorrow and grief, sobbing as if her heart would break," the newspaper reported, "suddenly the garment became detached and fell noiselessly to the ground, completely torn into fragments, and there is no cause assigned for the strange actions."

Women at the cemetery were confused by the strange event, but decorum prevailed. However, the incident was the only topic of conversation on the

An angry ghost destroyed a woman's underwear at a funeral held at Sisters Church in Washington County and then haunted the family home. *Earline Miles.*

trek home. There the daughter and other women immediately opened the closet where the second undergarment hung. Consternation arose when that article was found to be in the same shape as the other. A careful examination of both slips "found some parts of it perfectly sound, while other parts at the slight move or pinch would readily crumble to pieces. This is all a problem which will perhaps never be solved."

The case of the disintegrating petticoats was the talk of Washington County and encouraged the release of additional ghostly goings-on at the Watkins house, which had been kept confidential because such stories have "a tendency to decrease the value of the property," the paper noted.

The area around the house was occasionally brightly and beautifully illuminated. The phenomenon was "of a few minutes duration only and springs up in small places and vanishes like a vapor." Also, "a volley of pistol shots breaks the silence of the night," the account continued. But the greatest mystery was the "unlocking of doors," the paper proclaimed. Doors securely fastened by night at bedtime were found to be unlocked in the morning and occasionally open. Another baffling element were the "human voices" sometimes heard in and around the dwelling. There were other mysteries, but limited space in the paper forced their omission.

WILKINSON COUNTY

THE GRANNY CABINET

Sybil Willingham is a local historian in Taylor County. She sent me a true family story out of Wilkinson County that she titled "The Granny Cabinet."

While Sybil attended college in 1967, her widowed mother married a man named Crosby Brooks, a former Georgian who then lived in Florida, but he was willing to move into his new wife's home in Gordon.

Sybil, on college break, helped in the move. At Brooks's home, she was intrigued by a cabinet that sat in his garage, a strange place for such a piece. Crosby introduced the furniture as "Granny." Sybil described it as "an old pine wardrobe, a large rustic, primitive plantation piece." While driving though Jones County, he and his first wife saw it sitting on a front porch. Asking if it was for sale, they were told that it was built in about 1880 and had belonged to a family grandmother. The grandchildren "were anxious to get rid" of it, they found, and purchased it without wondering why the relatives were so eager to part with the piece. They soon discovered the reason.

When the cabinet was positioned in its new home, the owners found it impossible to keep the four-paneled door closed; it kept unlatching itself and swinging open. They repeatedly leveled the cabinet, changed the latch and placed it on different types of flooring. Over a period of twenty-five years, nothing worked. Crosby decided that the spirit of the lady who originally owned the piece inhabited the cabinet, and he dubbed her "Granny"—a benevolent spirit that only wanted to be noticed.

Spiritual life is important to many Georgians. This wall painting of *The Last Supper* advertises a restaurant. *Earline Miles.*

At the new home in Gordon, the cabinet was placed in a utility room, which was regularly used as an entrance from the garage to the kitchen. Sybil considered Granny a kind "spirit who would unlatch the door, sending [it] swinging open."

On many occasions, she personally watched as the latch came up and out, and the door swung open by itself. Some people were induced to "hurry through the utility room as quickly as possible. Even the dog gave wide berth

and hurried through the room, tail tucked and eyeing Granny suspiciously." Luckily, as Sybil noted, "No one ever saw Granny."

Alone in the house one day during spring break, Sybil heard a repeating noise from the utility room, located at the other end of the house. At length she investigated, finding "the door to Granny swinging back and forth and making a noise like the groan of a rusty hinge."

Crosby died in 1974, and Sybil's mother grew tired of the antics of the cabinet door and placed a heavy cooler against it. To this day, that "door still bears the scars from bumping against the cooler as it opened itself."

When Sybil's mother died in 1999, she placed the cabinet in her mother's bedroom, and the "door did not open again for nearly two years." Sybil had made her mother a number of bib aprons, which she had always worn while working around the house, and she could not bear to throw them out. As she removed the aprons from the wall hooks and placed them in a chest of drawers, the door of the Granny cabinet opened, as if in final tribute.

Moving day was two days later. As two beefy movers started toward the cabinet, they were startled. "Lady," one told Sybil, "this is the third time this latch has opened with us standing here looking at it. There's something weird going on here." Sybil introduced the men to Granny. The door had to be taped shut to prevent its unwanted movement.

The cabinet was placed in Sybil's office in a barn. Each time she entered the room, the door was always open. After she placed her mother's aprons in the cabinet, it remained shut. In a new house in town, the Granny Cabinet was placed with her mother's pie safe and kitchen chairs. Apparently, the grandmothers are satisfied, for the door only occasionally opens today.

BIBLIOGRAPHY

Allen, Roger. "A Ghostly Tale from Brooklet." *Statesboro Herald*, October 21, 2007.

Ancestry.com/Rootsweb. "Grand-Daddy, The Fortune Teller, and The Ghost." genealogy.rootsweb.ancestry.com.

Barnhill, Taylor. "Ghost Hunt in Harris County." WTVM.com-Columbus, August 16, 2009.

Bowers, Nancy. "Horror Is a State of Mind." *Augusta* (October 1, 1998).

Burns, Olive Ann. "The Ghosts of Samandka Make a Lot of Noise." *Atlanta Journal-Constitution*, May 11, 1973, Sunday Magazine section.

Burrison, John A. *Storytellers: Folktales & Legends from the South*. Athens: University of Georgia Press, 1989.

Calder, Andrew. "Hillsborough, GA." Paranormal Georgia Investigations, February 1, 2001. https://paranormalgeorgia.com.

Carden, Gary. "The Story of a Modern-Day Oracle." *Rocky Mountain News*, June 1, 2011.

Cashin, Edward J., and Daniel J. Cashin. *General Sherman's Girl Friend, and Other Stories about Augusta*. Columbia, SC: Woodstone Press, 1992.

Castle of Spirits. "Sometimes...You Wonder." http://www.castleofspirits.com/stories06/sometimes.html.

Davis, Will. "Laura's Night with the Ghouls." *Monroe County Reporter*, September 17, 2008.

Dobson, Wayne. "The Ghosts of Clinton Past." *Middle Georgia* (n.d.).

———. "Heritage Hall." *Middle Georgia* (n.d.).

Dolgner, Beth. *Georgia Specters and Spooks*. Atglen, PA: Schiffer Publishing, 2009.

Fabian, Liz. "Macon Man Leads Georgia Ghost Society in Its Spirit Pursuits." *Macon Telegraph*, October 28, 2007.

Falcons Life Forums. "Anybody on Here Ever Hear of Mahaley Lancaster?" December 27, 2008. http://boards.atlantafalcons.com/topic/3825720-anybody-on-here-ever-hear-of-mahaley-lancaster.

Fitch, Connie. "Jenkins County Ghost." Interview by author, June 12, 2009.

Giles, Bill. "Jenkins County Ghost." Interview by author, June 12, 2009.

Guthrie, Barbara. "Granddaddy's Last Visit." *FATE* (March 1, 1976).

Hall, Kristi. "Haunted Hot Spots." *Lakelife* (Fall 2008).

Harrell, Bob. "A Collection of Georgia's Most Elusive Apparitions." *Atlanta Constitution*, October 31, 1978.

Heard, B.N. "Memories of Mayhayley." Cranks My Tractor, October 5, 2010. http://www.cranksmytractor.com/2010/10/memories-of-mayhayley.html.

Heath, Chester H. *Spirit Photographs at Treasure Sites, Indian Signs and Symbols*. New York: Vantage Press, 1976.

Henson, Paige. "A Middle Georgia Ghostly Sampler." *Macon* (November–December 1989).

Huffman, Wade. "Jenkins County Ghost." Interview by author, June 12, 2009.

Irby, Mary Lee. *Ghosts of Macon*. Macon, GA: Vestige Pub., 1998.

Jackson, Cherie. "Griffin, Georgia Restaurant Visitor." Paranormal Research On-Line, February 7, 2002.

Javery, John. "Wheeler County Ghost." Telephone interview by author, September 27, 2014.

Joe. "Statesboro, Georgia Ghost Sightings." Ghosts of America. http://www.ghostsofamerica.com.

Johnson, Ronnie. "The Old Hall Place." *Swainsboro Forest-Blade*, June 17, 2013.

Karl. "Wrightsville, Georgia Ghost Sightings." Ghosts of America. http://www.ghostsofamerica.com.

Lady, Christian. "Preacher's Ghost Sneaks into My Bedroom at Night." *Weekly World News*, August 16, 2004.

Lane, Steve. "Meriwether County Ghost." Interview by author, September 12, 2009.

Leibowitz, Harriet. "House Hunting: Early Hill Has Been Degoated." *Brown's Guide to Georgia*, November 1980.

Leverette, Fannie. "Cradle Rocked by Disturbed Spirit." *Atlanta Journal*, November 12, 1933, Sunday Magazine section.

Loudermilk, Joey. "Recreation of Talbot's Ryder Murder Trial." *Talbottom New Era*, October 14, 2005.

Mary. "Statesboro, Georgia Ghost Sightings." Ghosts of America. http://www.ghostsofamerica.com.

Mason, Alex. "Haunted Crawford Jail." *Macon Telegraph*, October 30, 2007.

Mathis, Mark. "The Thompson Sightings." *Augusta Chronicle*, October 31, 1999.

Miles, Jim. "Personal Ghosts." *Brown's Guide to Georgia*, n.d.

———. *Weird Georgia: Close Encounters, Strange Creatures, and Unexplained Phenomena*. Nashville, TN: Cumberland House, 2000.

Miller, Stephanie. "Haints, Spirits, and Talking Cats." *Courier Herald*, October 27, 2004.

Moore, Libbi. *The Blue Lady of Ada'hi*. N.p.: Smashwords, 2012. https://www.smashwords.com/extreader/read/171799/1/the-blue-lady-of-adahi.

Norman, Michael, and Beth Scott. *Historic Haunted America*. New York: TOR, 1995.

Northeast Florida Paranormal Investigations. "Private Home in Guyton, GA." 2010.

Patterson, Tom. *St. EOM in the Land of Pasaquan: The Life and Times and Art of Eddie Owens Martin*. Winston-Salem, NC: Jargon Society, 1987.

Perkerson, Medora Field. *White Columns in Georgia*. New York: Rinehart, 1952.

Powell, Billy. *Echoes from the Valley*. Macon, GA: Indigo Custom Pub., 2006.

Richard, Hyatt. "Quiet, Sad, Ghost of St. Elmo Continues to Wait, to Hope, to Suffer." *Sunday Ledger-Enquirer*, October 31, 1982.

Salter, Charles. "Ghosts? No, but Footsteps Are There." *Atlanta Journal Constitution*, September 10, 1978.

———. "Some, but Not All, 'Ghosts' Join Family at Their New Home." *Atlanta Journal-Constitution*, July 4, 1989.

Sarah S. "The Ghosts of Seven Churches Road." Teen Ink. http://www.teenink.com/fiction/thriller_mystery/article/77680/The-Ghosts-of-Seven-Churches-Road/?page=5.

Savannah Morning News. "Mystery at Sisters Church." September 14, 1890.

———. "Peach Orchard Mystery." April 21, 1857.

———. "Witchcraft in Warren." April 21, 1857.

Schemmel, Ben. "The Ghost and Miss Katherine." *Georgia* (n.d.).

Sellers, Tom. *Valley Echoes*. Atlanta, GA: Davicone, 1986.

Smith, Gordon Burns, and Anna Habersham Wright Smith. *Ghost Dances and Shadow Pantomimes: Eyewitness Accounts of the Supernatural from Old Georgia*. Milledgeville, GA: Boyd Pub., 2004.

Smith, Sheron. "Spooky Tales to Help You Have a Haunted Halloween." *Macon Telegraph*, October 26, 1994.

St. John, Wylly. "Ghost that Eats Biscuits." *Atlanta Journal*, October 14, 1946, Sunday Magazine section.

Stripling, Gary. "Ghost Haunting 1830s St. Elmo Maintains Legend." *Columbus Ledger*, July 30, 1980.

Sutton, Jeff. "Chance of a Ghost." *Macon* (October 1, 2004).

Talbot Chamber of Commerce. "Tour Talbot County." http://talbotcountychamber.com/tour.

Thackston, Laura. "Guess Who's Staying at the Royal Palm Saturday Night?" *Monroe County Reporter*, September 10, 2008.

Thay, Edrick. "Mansions." *Ghost Stories of the Old South*. Edmonton, Alberta: Ghost House Books, 2003.

13WMAZ. "Ghost Hunters Visit Forsyth Inn." September 14, 2008. 13WMAZ.com.

Topix. "Mahaley Lancaster." http://www.topix.com/forum/city/bremen-ga/TSR9HPDPB03QT4U1L.

Torbett, Minerva. "The Ghost of Miss Mary." *FATE* (1985).

Wall, Larry. "Mr. Larkin and Yip." E-mail message to author, October 15, 2014.

Ware, Reuben Arnold. *Memories of a Linthead*. Savannah, GA: Linthead Pub., 1981.

Willingham, Sybil. "The Granny Cabinet." E-mail message to author, November 19, 2006.

———. "The Haunted Library Cabinet." E-mail message to author, March 1, 2007.

Windham, Kathryn Tucker. *13 Georgia Ghosts and Jeffrey*. Tuscaloosa: University of Alabama Press, 1987.

Your Ghost Stories. "Dark Hooded Figure in Ga." May 14, 2012. http://www.yourghoststories.com/real-ghost-story.php?story=15237.

ABOUT THE AUTHOR

Jim Miles is author of seven books of the Civil War Explorer Series (*Fields of Glory*, *To the Sea*, *Piercing the Heartland*, *Paths to Victory*, *A River Unvexed*, *Forged in Fire* and *The Storm Tide*), *Civil War Sites in Georgia* and two books titled *Weird Georgia*. Five books were featured by the History Book Club and he has been historical adviser to several History Channel shows. He has also written seven books about Georgia ghosts, *Civil War Ghosts of North Georgia*, *Civil War Ghosts of Atlanta*, *Civil War Ghosts of Central Georgia and Savannah*, *Haunted North Georgia*, *Haunted Central Georgia*, *Haunted South Georgia* and *Mysteries of Georgia's Military Bases: Ghosts, UFOs, and Bigfoot*. He has a bachelor's degree in history and a Master of Education degree from Georgia Southwestern State University in Americus. He taught high school American history for thirty-one years. Over a span of forty years, Jim has logged tens of thousands of miles exploring every nook and cranny in Georgia, as well as Civil War sites throughout the country. He lives in Warner Robins, Georgia, with his wife, Earline.

CPSIA information can be obtained
at www.ICGtesting.com
Printed in the USA
BVHW040818100619
550591BV00012B/735/P